The Age of Rembrandt

Dutch Paintings in The Metropolitan Museum of Art

Esmée Quodbach

The Metropolitan Museum of Art, New York

Yale University Press, New Haven and London

Sponsor's Statement

Accenture is pleased once again to partner with The Metropolitan Museum of Art and to be the exclusive sponsor of one of the most anticipated exhibitions coming to New York, "The Age of Rembrandt: Dutch Paintings in The Metropolitan Museum of Art." On view from September 18, 2007, through January 6, 2008, the exhibition marks the first time that all the Museum's Dutch paintings will be shown at the same time. The Metropolitan is home to the finest collection of Dutch art outside Europe, and the exhibition will reflect the appreciation for Dutch art in America and among New York's great collectors over the past two centuries.

Accenture is an enthusiastic supporter of significant cultural institutions and events that celebrate the human triumph made possible when knowledge, skill, and intellect work together to deliver high performance and innovation. These include, in addition to The Metropolitan Museum of Art, the Smithsonian National Museum of the American Indian, the High Museum of Art, Atlanta, the Royal Shakespeare Company, the Teatro alla Scala, Milan, and the British Film Institute, London.

As one of the world's leading management consulting, technology services, and outsourcing organizations, Accenture mobilizes the power of teaming to deliver high performance and innovation to our clients and partners around the world. On behalf of the more than 152,000 Accenture people worldwide, we invite you to explore "The Age of Rembrandt: Dutch Paintings in The Metropolitan Museum of Art" and to experience this extraordinary exhibition.

The author wishes to thank Walter Liedtke for his many valuable comments and Sue Potter for her expert editing.

Reprint of *The Metropolitan Museum of Art Bulletin* (Summer 2007). Copyright © 2007 by The Metropolitan Museum of Art.

The exhibition is made possible by **>accenture** High performance. Delivered.

This issue of the *Bulletin* is supported by Hata Stichting Foundation.

This publication is made possible through the generosity of the Lila Acheson Wallace Fund for The Metropolitan Museum of Art, established by the cofounder of *Reader's Digest*.

Publisher and Editor in Chief: John P. O'Neill
Editor of the *Bulletin*: Sue Potter
Production: Christopher Zichello
Design: Bruce Campbell

New photographs of works in the Museum's collections are by Juan Trujillo, The Photograph Studio, The Metropolitan Museum of Art. Additional photographs were supplied by credited institutions, unless otherwise noted here. Fig. 17: Tomkins 1970, p. 370; 18: Tate, London / Art Resource, New York; 53: photograph by Moses King; 61: © 2007 by The New York Times Co., reprinted with permission; 62: photograph by Blackstone Studios, Inc., New York; 73: *Avenue*, June/July/August 1983, p. 63.

Front cover: Rembrandt van Rijn (Dutch, 1606–1669). *Flora*, probably ca. 1654 (Fig. 26)
Back cover: Jacob van Ruisdael (Dutch, 1628/29–1682). *Wheatfields*, ca. 1670 (Fig. 36)
Frontispiece: Johannes Vermeer (Dutch, 1632–1675). *Young Woman with a Water Pitcher*, ca. 1662 (Fig. 8)

Cataloging-in-Publication data is available from the Library of Congress.
ISBN: 978-1-58839-226-8 (The Metropolitan Museum of Art)
ISBN: 978-0-300-12406-4 (Yale University Press)

Printed and bound in the United States of America.

Director's Note

This special issue of the *Bulletin* anticipates the exhibition "The Age of Rembrandt: Dutch Paintings in The Metropolitan Museum of Art," which will be presented at the Museum from September 18, 2007, through January 6, 2008, and generously supported by Accenture. The essay, by Dutch scholar Esmée Quodbach, describes how the collection grew from twenty-three Dutch works that were part of the Museum's first purchase in 1871 to one of the most distinguished ensembles of Dutch paintings in the world. All of the Museum's Dutch paintings dating from about 1600 to 1800—at present there are 228, all but nine from the seventeenth century—are discussed at length in Walter Liedtke's standard collection catalogue, published in September 2007.

As Curator of European Paintings and that department's specialist for Dutch and Flemish art, Liedtke might have taken the opportunity to write this *Bulletin* himself. He eagerly put forward Esmée Quodbach's name, however, on the basis of her articles about collecting in the United States, one of which, "'Rembrandt's "Gilder" Is Here': How America Got Its First Rembrandt and France Lost Many of Its Old Masters" (*Simiolus,* 2004), centers on Rembrandt's portrait of the ebony worker Herman Doomer (Fig. 12) and the Museum's celebrated benefactors Louisine and Henry O. Havemeyer. In addition to working as Research Assistant in the Department of European Paintings at the Museum, where she was Liedtke's choice as the new Dutch catalogue's first critical reader, Ms. Quodbach is completing her doctoral dissertation at the University of Utrecht, on "Rembrandt in America." She also recently became Assistant to the Director of the Center for the History of Collecting in America at the Frick Collection in New York.

Like the Havemeyers, other leading collectors in the Gilded Age had strong views about which Dutch masters mattered most. Benjamin Altman bought superb paintings by the holy trinity of Dutch art (Hals, Rembrandt, and Vermeer) and by the immortals of Dutch landscape (Ruisdael, Hobbema, Cuyp), adding no more than another quartet (Ter Borch, Dou, De Hooch, and Maes) to the artists responsible for the two dozen Dutch pictures he left to the Museum in 1913. The encyclopedic collector John G. Johnson, of Philadelphia, complained to Bernard Berenson that Altman was one of those who "know, especially since [the dealer] Mr. Joseph Duveen has confirmed the fact, that Rembrandt is a great artist." What Altman also knew is that his collection would go to the Museum, which at the time had several dozen Dutch pictures but only two masterpieces by the major artists: a Hals and a Vermeer that the railroad financier Henry Marquand had donated in the late nineteenth century.

Quodbach traces the contributions that curators, trustees, and above all collectors such as the Havemeyers, Marquand, Altman, Collis and Arabella Huntington, J. P. Morgan, William Vanderbilt, Michael Friedsam, Jules Bache, and Robert Lehman have made to the Museum's holdings of Dutch paintings in the 137 years since the Museum's founding. And her lively commentary also brings to life revealing aspects of American culture, viewed from slightly offshore.

Philippe de Montebello
Director

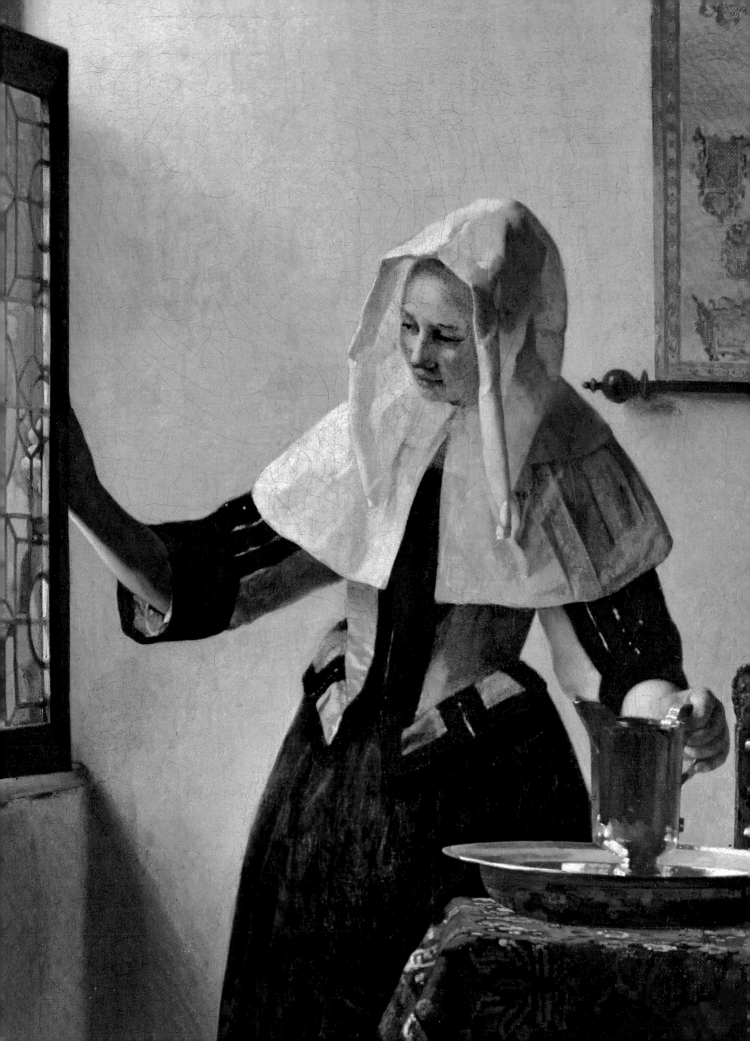

The Age of Rembrandt
Dutch Paintings in The Metropolitan Museum of Art

"We are just in the stir and bustle of preparing to open the Museum. The pictures are hung and look remarkably well," John Taylor Johnston (1820–1893), the Metropolitan Museum's first president, wrote to William Tilden Blodgett (1823–1875), its vice-president, on February 10, 1872. "Much will depend . . . on how our pictures take with the public." Ten days later, on February 20, the fledgling Museum opened to the public in the Dodworth Building, a former dancing academy at 681 Fifth Avenue (Fig. 1). On view was the institution's founding collection of 174 European old master paintings—the so-called Purchase of 1871—the acquisition of which Blodgett had organized in Paris the previous year, in the midst of the chaos caused by the Franco-Prussian War. Blodgett, a prominent publisher and art collector who had retired to the French capital, had used his own resources to secure the pictures, which came from private collections in Belgium and France. He paid $100,000 for the lot. Some six months later, in March 1871, the Museum's trustees voted to buy the paintings from him for the purchase price plus costs.

According to the catalogue published on the occasion of the 1872 opening, the Purchase of 1871 included works by such esteemed masters as Italians Paris Bordone, Francesco Guardi, and Giovanni Battista Tiepolo; Spaniards Diego Velázquez and Francisco Goya; and Frenchmen Nicolas Poussin and Jean Baptiste Greuze. But the majority of the paintings Blodgett bought for the Museum belonged to the Dutch and Flemish schools, then perhaps the most coveted on both sides of the Atlantic. Among the Flemish works were paintings by Peter Paul Rubens, Anthony van Dyck, and David Teniers the Younger. Among the Dutch were three pictures by Salomon van Ruysdael (see Fig. 2), a landscape by Jan van Goyen (Fig. 3), and a portrait then thought to be by Frans Hals (Fig. 4), one of the most beloved artists of the Dutch Golden Age in the late nineteenth century.

After the Museum's official opening, a content Johnston informed Blodgett that the "fine turnout of ladies and gentlemen" had

1. Opening reception in the picture gallery at The Metropolitan Museum of Art, 681 Fifth Avenue, February 20, 1872 (wood engraving published in *Frank Leslie's Illustrated Newspaper*, March 9, 1872)

NEW YORK CITY.—OPENING RECEPTION OF THE METROPOLITAN MUSEUM OF ART, AT THE TEMPORARY HALL, NO. 681 FIFTH AVENUE, FEBRUARY 20TH.

2. Salomon van Ruysdael (Dutch, 1600/1603–1670). *Drawing the Eel*, 1650s. Oil on wood, 29½ x 41¾ in. (74.9 x 106 cm). Purchase, 1871 (71.75). One of three paintings by Van Ruysdael to enter the Museum in 1871, this scene remains the finest among the seven works by the artist in its collections.

all been "highly pleased." The newly acquired paintings were "splendidly" displayed, and compliments had been "plenty and strong." Indeed, the invitees had been "generally surprised, and agreeably so" to find what the Museum already had in its possession, for no one had imagined that they could make such a show. "The disposition to praise," Johnston wrote, "is now as general as the former disposition to depreciate. . . . We may now consider the Museum fairly launched and under favorable auspices."

One critic who came to see New York's new museum was the young Henry James (1843–1916), who published his reaction (anonymously) in the *Atlantic Monthly* in June 1872. The authenticity of the collection of pictures recently "lodged in a handsome and convenient gallery, masked by one of the residential brown-stone fronts of the Fifth Avenue," James said,

has in each case been attested by proper evidence and by the judgment of experts, and in possessing them the Metropolitan Museum of Art has an enviably solid foundation for future acquisition and development. It is not indeed to be termed a brilliant collection, for it contains no first-rate example of a first-rate genius; but it may claim within its limits a unity and continuity which cannot fail to make it a source of profit to students debarred from European opportunities. If it has no gems of the first magnitude, it has few specimens that are decidedly valueless.

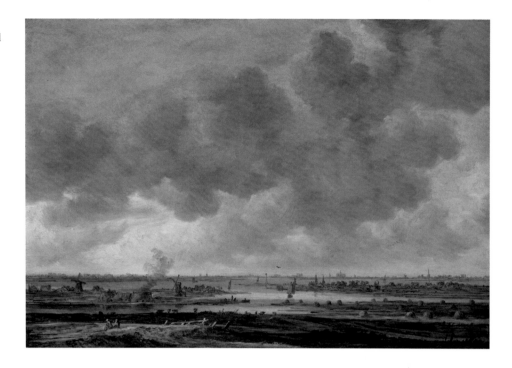

3. Jan van Goyen (Dutch, 1596–1656). *View of Haarlem and the Haarlemmer Meer*. Oil on wood, 13⅝ x 19⅞ in. (34.6 x 50.5 cm). Purchase, 1871 (71.62)

The chief strength of the Museum's 1871 Purchase, James readily acknowledged, lay in its Dutch and Flemish pictures, especially some of the genre pieces, landscapes, and "rustic groups." He singled out three "capital" Salomon van Ruysdaels (see Fig. 2), a "lovely" Nicolaes Berchem, a "charming" Caspar Netscher, a "fine" Jan Steen, an "interesting" Meyndert Hobbema, and an "elegant" Margareta Haverman (Fig. 5). He paid Bartholomeus van der Helst's *Portrait of a Man* a more ambiguous compliment, describing it as "the perfect prose of portraiture." He had dubious praise as well for the loosely painted portrait of a Haarlem street wench known as Malle Babbe, or Mad Barbara, whom James and his contemporaries mistakenly called Hille Bobbe (Fig. 4). The painting was "a masterpiece of inelegant vigor," according to James, "in hardly more than two or three gradations of brown, but it is instinct with energy and a certain gross truth. The face is a miracle of ugliness; but it is noticeable how little of fantasy, of imaginative irony, there is in the painter's touch." (Although it was then attributed to Frans Hals, at present the picture is thought to be a seventeenth-century Dutch copy after Hals's original of the 1630s, now in the Gemäldegalerie, Berlin.)

In fact, James found not a single "humble masterpiece" among the Museum's new Dutch pictures that had "anything that one may call imagination." He was not alone. Like other scholars, critics, and art collectors on both sides of the Atlantic at the time, he thought the masters of seventeenth-century Holland painted what they saw, nothing more and nothing less. To influential French critics like Théophile Thoré (1807–1869), who wrote under the pseudonym W. Bürger, and Eugène Fromentin (1820–1876), the art of the Dutch Golden Age was merely a portrait of Holland and its people, and their many followers in Europe and America would take the same view for decades to come. Yet despite the Dutch masters' alleged lack of imagination, Henry James was nonetheless willing to hold them up as examples to his fellow Americans, in

4. Style of Frans Hals (Dutch, second quarter 17th century). *Malle Babbe*. Oil on canvas, 29½ x 24 in. (74.9 x 61 cm). Purchase, 1871 (71.76)

particular to aspiring artists. After all, he concluded, "imagination is not a quality to recommend; we bow low to it when we meet it, but we are wary of introducing it into well-regulated intellects. We prefer to assume that our generous young art students possess it, and content ourselves with directing them to the charming little academy in the Fifth Avenue for lessons in observation and execution."

Some three months after the Metropolitan Museum opened to the public, its superintendent proudly reported that its visitors already numbered nearly 6,000, "including Artists, Students, Critics, and Amateurs from other cities." Their verdict had "not only been favorable, without exception," but also, in nearly every instance, they had expressed "very agreeable surprise" with regard to the interest and excellence of the Museum's pictures. "Those persons especially who appear to be most familiar with the Galleries of Europe, and with Art generally, have been most emphatic and enthusiastic in their remarks on our pictures." All in all, the Purchase of 1871 has held up quite well. Although over the years the Museum has deaccessioned 110 of the original 174 pictures because they were

5. Margareta Haverman (Dutch, active ca. 1715–in or after 1723). *A Vase of Flowers*, 1716. Oil on wood, 31¼ x 23¾ in. (79.4 x 60.3 cm). Purchase, 1871 (71.6). Haverman was the only pupil of Amsterdam artist Jan van Huysum (1682–1749), the leading still-life painter of his day. Van Huysum, said to be intensely secretive about his techniques, reportedly became so jealous of his pupil's work that he forced her to leave his studio. About 1720 Haverman moved to Paris. In 1722 she became the second woman to be elected to the Académie Royale in the eighteenth century, but she was expelled a year later, after members claimed her reception piece was in fact by her former teacher. This is one of only two paintings by Haverman known today.

either copies, badly preserved authentic paintings, or works of the second or third rank, 64 of them are still in its collection today, and 23 of those belong to the Dutch school.

Despite its ambitious beginnings, in its first decade the Museum acquired hardly any further paintings. In September 1873, just months after the collections were moved from the Dodworth Building to the more fashionable Douglas Mansion on West Fourteenth Street, a deep financial depression, one of the worst in American history, struck the country. The economy began recovering from the so-called Panic of 1873 in 1877, but even in the early 1880s, after the Museum had relocated to its current site on Fifth Avenue, the pace of acquisition remained slow. Still, it was in these years that some of New York's foremost new collectors and dealers started to buy important old master pictures in Europe, often profiting from the dire financial circumstances of the Old World's aristocrats, many of whom were forced to sell their most prized paintings in order to keep their estates. The United States, by contrast, underwent a

period of unprecedented growth in the late nineteenth century as industry boomed, trade flourished, and railroad networks spread across the land. It was the spectacular rise in private income that permitted the new millionaires of the Gilded Age to give sums of money to the country's newly founded art museums and, often in addition, build collections of their own.

"There was money in the air, ever so much money. . . . And the money was to be for all the most exquisite things," Henry James wrote about the collecting craze in New York in the 1880s. "With the coming of the new millionaires the building of big houses had begun, in New York and in the country, bringing with it . . . a keen interest in architecture, furniture and works of art in general," noted James's friend Edith Wharton (1862–1937), herself a daughter of a prominent old New York family, in her memoir, *A Backward Glance*. The leading dealers from London and Paris seized the opportunity to educate a new clientele, open branches in New York, and mount loan exhibitions. Moreover, in the late nineteenth century the young Metropolitan Museum awoke from "its long lethargy," as Wharton called it. In 1886 the Department of Paintings was created to administer not just the paintings but also all the prints and drawings that came to the Museum. Soon after, in 1887, the New York tobacco heiress Catharine Lorillard Wolfe (1828–1887), allegedly the world's wealthiest unmarried woman, gave the Museum a large group of fashionable contemporary French works, plus an endowment of $200,000. In 1888 Coudert Brothers donated a number of old masters, mostly early Italian works. Neither gift included any Dutch works.

The first collector to present the Metropolitan with a number of significant Dutch pictures was Henry G. Marquand (1819–1902), a railroad financier and one of New York's "new millionaires." Marquand (Fig. 6) had been a supporter of the Museum from its founding year, and he became its treasurer in 1882 and its second president in 1889. Though his tastes were rather conventional and his personal collection consisted mostly of contemporary French and American anecdotal paintings, he set out in the early 1880s to assemble a group of first-class old masters specifically for the Museum, buying up art "like an Italian Prince of the Renaissance." In 1883 he acquired the picture that was perhaps the first authentic Rembrandt to come to the United States, *Portrait of a Man* (Fig. 7). "I have bought today a remarkable Rembrandt, an old man very like the Burgomaster Six [a reference to Rembrandt's *Portrait of Jan Six* in the Six Foundation, Amsterdam] . . . [for] twenty five thousand dollars," Marquand's agent, the American Impressionist J. Alden Weir (1852–1919), wrote to his parents after he had purchased the painting at Agnew's in London. Of all the pictures Weir had ever seen for sale, he thought this Rembrandt was the finest, "a gem of the first water" that America would be proud of. The canvas came from one of Britain's most revered collections, that of the fifth Marquess of Lansdowne, who, as Weir noted in his letter, was forced to part with some of his pictures, "owing to his estates in Ireland not paying."

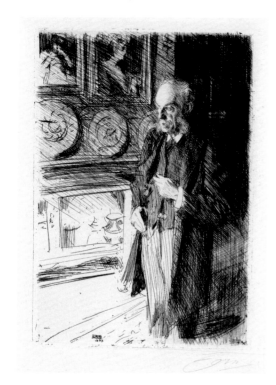

6. Anders Leonard Zorn (Swedish, 1860–1920). *Henry Gurdon Marquand (1819–1902)*, 1893. Etching, 11 x 7¾ in. (27.8 x 19.8 cm). A. Hyatt Mayor Purchase Fund, Marjorie Phelps Starr Bequest, 1978 (1978.545.2)

7. Rembrandt van Rijn (Dutch, 1606–1669). *Portrait of a Man*, possibly 1650s. Oil on canvas, 32⅞ x 25⅜ in. (83.5 x 64.5 cm). Marquand Collection, Gift of Henry G. Marquand, 1890 (91.26.7)

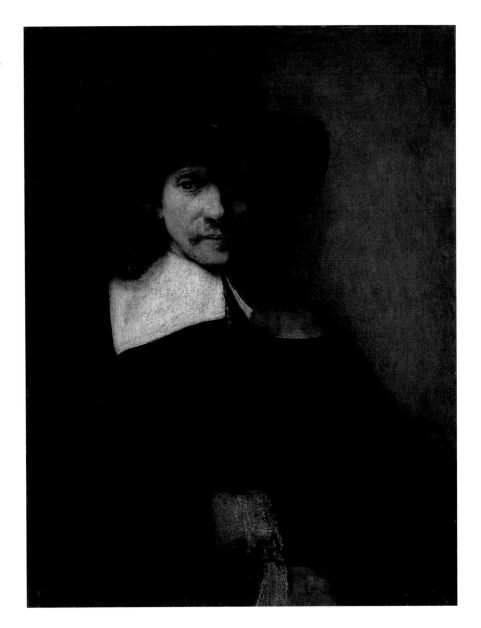

After the sale of his Rembrandt, Lord Lansdowne was severely upbraided by the London *Times* for bartering away this and other heirlooms to an American, for "most persons would have supposed [him] to have been as likely to part with the bones of his ancestors as to part with the family collection to a foreigner." Marquand, on the other hand, was delighted with Weir's "great scoop." "What a gorgeous thing! You can't tell how I feel and how proud I am to get it," he wrote to Weir after he had seen the painting for the first time. "If one thing in a year could be had, what a gallery I could get in time." Five years later, in 1889, Marquand bought another "Rembrandt" in England for the Museum, the *Man with a Beard* that is still part of the collection. It is now thought to be a later imitation.

Marquand also gave the United States what may have been its first authentic work by Johannes Vermeer (there are now thirteen in the country), *Young Woman with a Water Pitcher* (Fig. 8). Vermeer, or the "Sphinx of Delft" as Théophile Thoré (who "rediscovered" Vermeer) called him, was also an art dealer. He painted

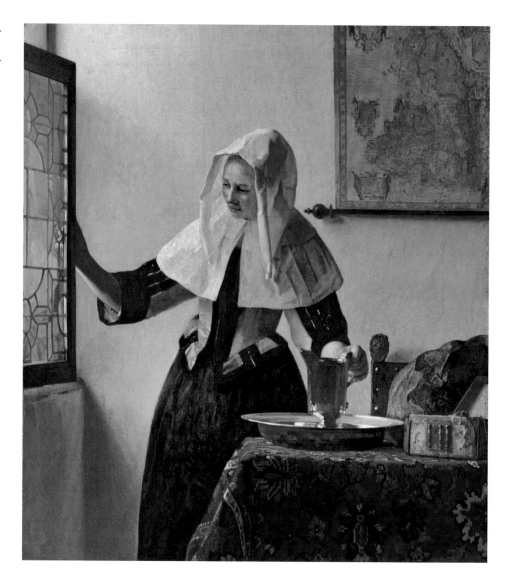

relatively few pictures, and only some thirty-six are regarded as autograph by most modern scholars. Little is known about the early history of *Young Woman with a Water Pitcher*, an unsigned canvas of about 1662. It was long ascribed to Gabriël Metsu, the genre painter whose fine cabinet pieces (see Fig. 42) fetched high prices in the eighteenth and nineteenth centuries and whose reputation still far surpassed Vermeer's in the early years of the Gilded Age. Indeed, *Young Woman with a Water Pitcher* had been sold as a Metsu in 1878 to an Irish aristocrat, Lord Powerscourt, who soon became convinced of Vermeer's authorship. Henry Marquand acquired Powerscourt's painting (as a Vermeer) in 1887 from a Paris dealer for a modest $800.

In 1889 Marquand included *Young Woman with a Water Pitcher*, the best of the five Vermeers that are now part of the collection, in his first grand gift to the Museum, thirty-seven paintings valued then at at least half a million dollars. A second gift of fifteen pictures, including Frans Hals's *Portrait of a Man* (Fig. 9), followed in 1890. In 1897 *Harper's Weekly* published a print of "The Marquand Gallery" at the Metropolitan (Fig. 10). The New York financier was "one of the

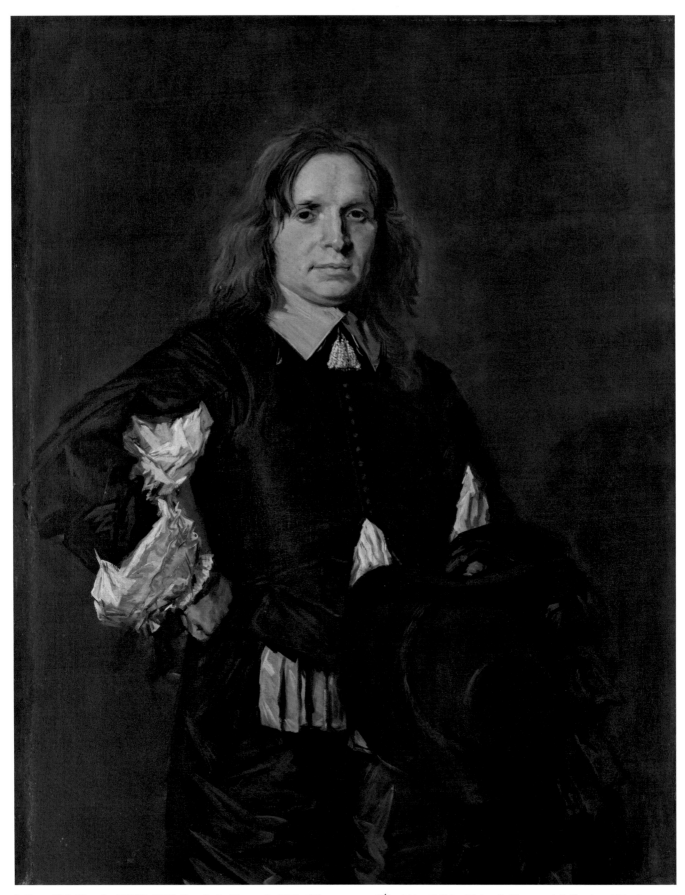

9. Frans Hals (Dutch, 1582/83–1666). *Portrait of a Man*, early 1650s. Oil on canvas, 43$\frac{1}{2}$ x 34 in. (110.5 x 86.4 cm). Marquand Collection, Gift of Henry G. Marquand, 1890 (91.26.9)

10. *The Marquand Gallery of Old Masters at The Metropolitan Museum of Art*, 1897. Print, 5¼ x 8 in. (14 x 21 cm). Among the paintings on the right wall are, from left to right, Anthony van Dyck, *Portrait of a Man*; Adriaen Hanneman, *Portrait of a Woman* (center section, upper left); Frans Hals, *Portrait of a Man* (center section, lower left); Jürgen Ovens, *Portrait of a Woman* (center section, upper row center); Frans Hals, *Portrait of a Woman* (center section, lower right), at the time thought to be a portrait of the artist's wife. On the back wall in the center is Anthony van Dyck, *James Stuart (1612–1655), Duke of Richmond and Lennox*; at the far right is *Mariana of Austria (1634–1696), Queen of Austria*, acquired as a Diego Velázquez but now attributed to the master's workshop; and above that is Fra Filippo Lippi's *Portrait of a Woman with a Man at a Casement*, bought as a Masaccio.

men among us who have looked beyond the present," the *Collector* said in 1892, referring to his unflagging efforts to bring old master paintings to the United States. Marquand, who immediately gave most of his acquisitions to the Metropolitan, was "the greatest collector in America, because he [collected] not for himself alone, but for a whole people and for all the world." Marquand served as the Museum's president until his death in 1902, and he continued to donate paintings to its collections, among them, in 1895, Pieter de Molijn's fine *Landscape with a Cottage* of 1629. Almost a century later, in 1974, Marquand funds were used to partially finance the purchase of an exceptional panel by Jacques de Gheyn the Elder, *Vanitas Still Life* of 1603 (Fig. 69).

New York sugar magnate Henry O. ("Harry") Havemeyer (1847–1907) and his wife, Louisine (1855–1929), were also buying old masters in Europe in the 1880s. The Havemeyers (Fig. 11), as one of their biographers has said, had "the position, courage and taste to be 'different.'" The young Louisine probably made her first art purchase in Paris in 1877, when she paid 500 francs (about $100) for a Degas pastel, *Ballet Rehearsal* of about 1876 (Nelson-Atkins Museum of Art, Kansas City), on the advice of her good friend Mary Cassatt (1844–1926), notably at a time when hardly anyone showed any interest in Degas's work. After their marriage in 1883, both Mr. and Mrs. Havemeyer purchased numerous works of art for their collection. Their artistic tastes continued to be shaped by Cassatt, who spent her entire adult life in Paris amid the French avant-garde. In addition, the

11. Henry O. ("Harry") Havemeyer
(1847–1907) and his wife, Louisine
(1855–1929), in Paris, 1889

Havemeyers were influenced by the Paris dealer Paul Durand-Ruel (1831–1922), the avant-garde's main champion as well as a respected dealer in old masters. More indirectly, the Havemeyers' preferences were fashioned by the critics and art historians whose views were in vogue on both sides of the Atlantic, among them the late Théophile Thoré, whose penchant for Rembrandt, Hals, and the Dutch school they (or perhaps more accurately he) largely adopted.

The Havemeyers are still well known today as pioneer collectors of the Impressionists; they assembled the finest and largest collection of Impressionist art outside Paris. Yet it has been all but forgotten that the couple were also the United States' first great Rembrandt collectors. Harry Havemeyer bought his first two Rembrandts, the so-called Van Beresteyn portraits of 1632 (*Portrait of a Man* and *Portrait of a Woman*, both now in the Metropolitan), in the winter of 1888 for a hefty $60,000 for the pair, his most expensive purchase to date. Just a few months later, in March 1889, he truly made his mark as a collector of old masters when he acquired Rembrandt's exquisite *Herman Doomer* of 1640 (Fig. 12), the departure of which for the States a few years earlier had made waves in France. Havemeyer reportedly paid about $80,000 for the exceptionally well-preserved Rembrandt, which may have been the highest price paid for any Dutch picture in the nineteenth century.

Within four years the Havemeyers had purchased five other works then thought to be by Rembrandt, all from renowned French collections, the best three of which were later bequeathed to the Museum: the pendants *Portrait of a Man with a Breastplate and Plumed Hat* and *Portrait of a Woman*, now catalogued as "Style of Rembrandt," and *Portrait of an Old Woman*, now listed as "Style of Jacob Backer." They also acquired several other first-rate Dutch pictures in Paris, among them Pieter de Hooch's then famous *The Visit* of about 1657 (Fig. 13), which in the 1860s Théophile Thoré had given to Vermeer, for a grand 276,000 francs (about $55,200), and two small oval portrait pendants of 1626 by the much admired Frans Hals, for 91,000 francs (about $18,200). Their collection of Dutch pictures, although quite small, was glorious by any contemporary standard, even though the majority of their coveted Rembrandts are no longer attributed to the master. "I am quite sure that no other person owns eight examples of the works of Rembrandt as beautiful as the eight Rembrandts which are in one room of Mr. H. O. Havemeyer's house in the Fifth Avenue," the great German Rembrandt scholar and museum director Wilhelm Bode (1845–1929) told the *New York Times* during his first journey to the United States in 1893. According to Bode (Fig. 14), who was one of the first Europeans to visit the celebrated "Rembrandt Room" in the Havemeyers' newly built mansion on the corner of East Sixty-sixth Street and Fifth Avenue (Fig. 15), their collection

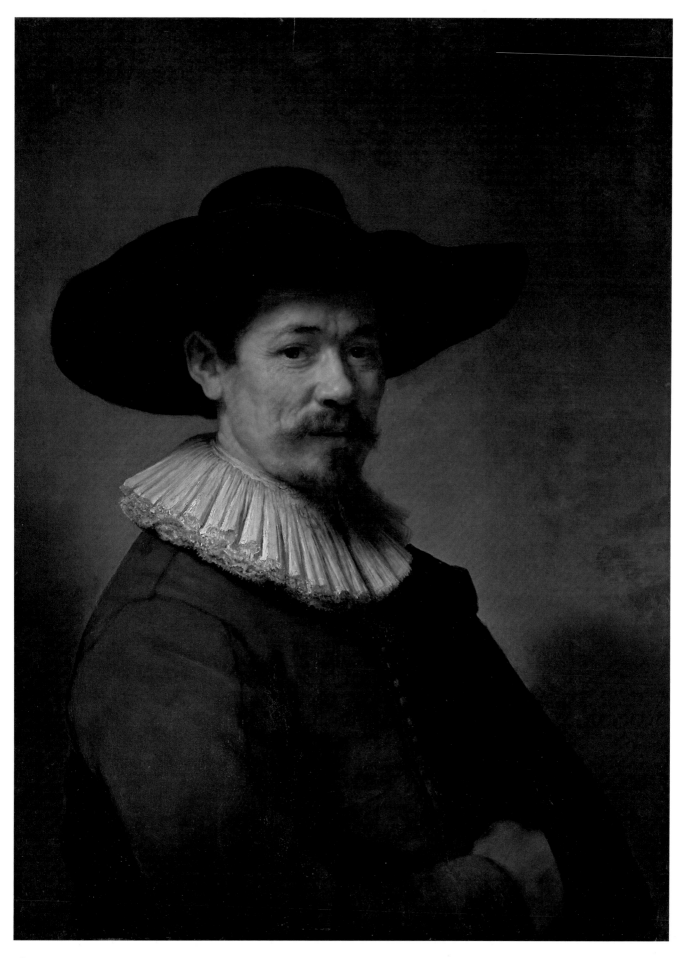

12. Rembrandt van Rijn (Dutch, 1606–1669). *Herman Doomer*, 1640. Oil on wood, 29⅝ x 21¾ in. (75.2 x 55.2 cm). H. O. Havemeyer Collection, Bequest of Mrs. H. O. Havemeyer, 1929 (29.100.1). In 1750 Rembrandt's portrait of the renowned Amsterdam ebony worker Herman Doomer (ca. 1595–1650) was separated from its pendant, *Baertje Martens*, now in the Hermitage, Saint Petersburg. Sometime in the eighteenth century Doomer's identity was forgotten, and Rembrandt's celebrated panel became widely known as *The Gilder* (or *Le doreur*). By 1854 it was the centerpiece of the collection of Duke Auguste de Morny (1811–1865), an influential politician and one of the great collectors of Second Empire Paris.

was, despite its then still limited size, "by far the most important one" in New York. The New World surprised Bode, who was one of the main tastemakers for Dutch art in the Gilded Age. "The public feeling for art," he told the *New York Times*, "the architecture, the fortunes spent in public and private collections, the general interest in doing things that are magnificent, are the characteristics of which I constantly think." As yet, Bode was not afraid of American competition in the international art market, as at that point no American collectors were systematically acquiring old masters. He did observe, however, that Americans had good taste and chose to buy high-quality pictures rather than merely famous names. Within a few decades, he later wrote in his travel notes with almost visionary prescience, America would be a country that one needed to visit for its collections of old masters. The Havemeyers' gift of nearly 2,000 paintings and other objects came to the Museum in 1929.

Another late nineteenth-century collector whose pictures would come to the Museum in the 1920s was Collis P. Huntington (1821–1900), originally of Harwinton, Connecticut, and one of the "Big Four" who built the Central

13. Pieter de Hooch (Dutch, 1629–1684). *The Visit*, ca. 1657. Oil on wood, 26¾ x 23 in. (67.9 x 58.4 cm). H. O. Havemeyer Collection, Bequest of Mrs. H. O. Havemeyer, 1929 (29.100.7)

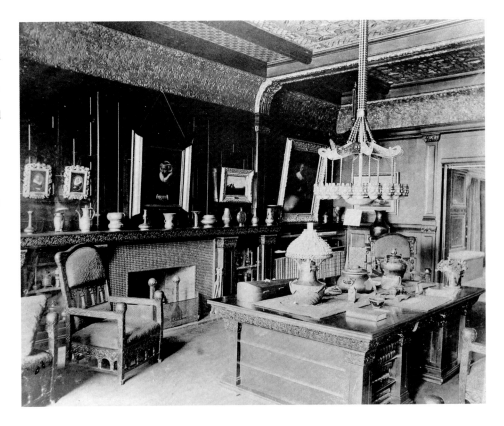

15. The library or "Rembrandt Room" in the Havemeyer residence at 1 East Sixty-sixth Street, New York, which was built in 1889–90 and decorated in 1890–92. Hanging from left to right are Frans Hals, *Petrus Scriverius* and *Anna van der Aar*, 1626; Style of Jacob Backer (formerly attributed to Rembrandt), *Portrait of an Old Woman*, 1640; an unidentified landscape; and Rembrandt, *Portrait of a Man*, 1632 (one of the so-called Van Beresteyn portraits). All but the unidentified landscape came to the Museum as part of the Havemeyer Bequest in 1929.

14. Wilhelm Bode (1845–1929), ca. 1905 (?)

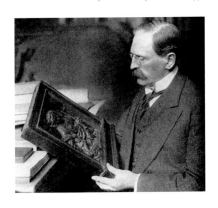

Pacific Railroad. Huntington's collection, much more so than the Havemeyers', reflected the typical taste of the Gilded Age for the Barbizon school and the British portraitists. Still, his bequest to the Museum of 188 paintings also included a number of Dutch pictures, among them several fine Rembrandtesque works such as an early canvas by Gerbrand van den Eeckhout, *Isaac Blessing Jacob* of 1642, and a *tronie* on panel by Govert Flinck, *Bearded Man with a Velvet Cap* of 1645.

Huntington's chief Dutch painting was his Vermeer, *Woman with a Lute* of about 1662–63 (Fig. 16). He later told the *New York Times* that he knew "nothing" about Vermeer and the artist's growing reputation when the picture was offered to him in Paris in the late nineteenth century; he simply "took a fancy" to it and purchased it for a mere 2,000 francs (about $400). One of the first Vermeers to cross the Atlantic, *Woman with a Lute* remained virtually unknown until Huntington's widow, Arabella (1850–1924; see Fig. 20), lent it to the so-called Hudson-Fulton Celebration held at the Metropolitan Museum in 1909. "It is this picture, without provenance and without history, until now uncatalogued and undescribed, which is that pearl of price, a perfect work in perfect condition of the most perfect painter that ever lived," the critic Kenyon Cox wrote after he had seen the Vermeer there. Huntington bequeathed *Woman with a Lute* (which, contrary to Cox's statement, is somewhat worn) to the Museum in 1900, but it and his other pictures were not accessioned until 1925, the year after the death of Arabella Huntington, who had become a leading collector in her own right.

At the turn of the twentieth century New York was about to become "a paradise for dealers," the Paris dealer Germain Seligman (1893–1978) wrote in his

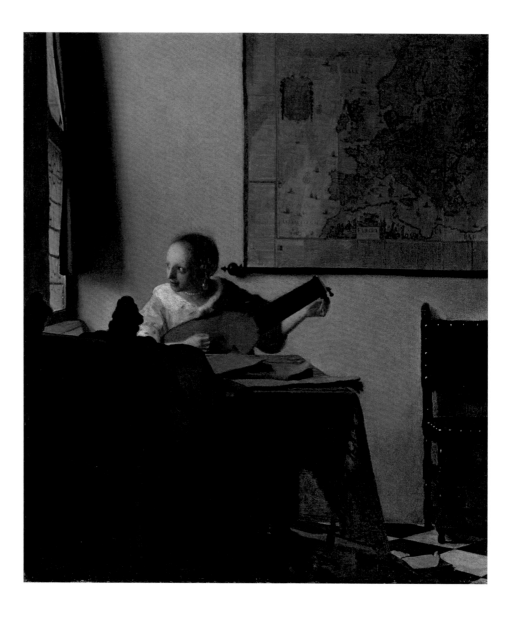

16. Johannes Vermeer (Dutch, 1632–1675). *Woman with a Lute*, probably ca. 1662–63. Oil on canvas, 20¼ x 18 in. (51.4 x 45.7 cm). Bequest of Collis P. Huntington, 1900 (25.110.24)

17. Jacob S. Rogers (d. 1901)

memoir, *Merchants of Art* (1961). Until then, the American art market had not been impressive, as it comprised only a handful of clients who returned to Europe year after year. Indeed, Seligman argued, though many Americans bought lavishly in the late nineteenth century, the total they spent was still small compared to the sums that Europe's up-and-coming collectors spent on their acquisitions, and with few exceptions, American buying was as yet "indiscriminate." America's museums were for the most part "still in their infancy"; their vast endowments were still "far in the future," and they had little buying power. Europe's indifference to the U.S. dollar—"erratic and unstable in comparison with the louis d'or and the gold pound"—also played a role, but, Seligman noted, "this was changing rapidly!"

New opportunities for the Museum arose in the early years of the twentieth century when it received an unanticipated bequest of $5,000,000 from an occasional visitor, Jacob S. Rogers of Paterson, New Jersey (Fig. 17). A highly eccentric character, Rogers was president of Rogers Locomotive and Machine Works, one of the most successful steam locomotive manufacturers in late nineteenth-century

America. Nearly every year from 1883 until his death in 1901, he came to the Museum in person to pay his annual membership dues of $10. Unlike the great majority of the Museum's grand donors of the Gilded Age, Rogers was not a collector himself; he apparently owned just a handful of less than mediocre pictures by unknown modern artists at the time of his death. "Who Mr. Rogers was, what he did during his lifetime, and why he should have left so large a sum of money to the Museum, are questions frequently asked and seldom answered," wrote an acquaintance not long after his death.

As a result of Rogers's unexpected generosity, the Museum suddenly found itself with a large endowment fund, the annual income from which—a substantial $200,000—was to be used "for the purchase of rare and desirable art objects, and in the purchase of books." Rogers's exceptional bequest not only made headlines in the national newspapers, it also transformed the Metropolitan Museum from a well-regarded yet struggling institution into a strong contender on the international art market. The trustees could barely believe their good fortune. "The wonderful will of Jacob Rogers with its splendid possibilities for the museum has astonished us all greatly," one of them wrote to Henry Marquand, then the Museum's president. "It seems like a golden dream." Rogers's generous posthumous gift would enable the Museum to build its collections according to "a comprehensive scientific plan," as Robert de Forest (1848–1931), secretary of the board of trustees, wrote in the Museum's Annual Report for 1905. The trustees would no longer aim merely to "assemble beautiful objects and display them harmoniously, still less to amass a collection of unrelated curios"; they could now "group together the masterpieces of different countries and times in such relation and sequence as to illustrate the history of art in the broadest sense, to make plain its teaching and to inspire and direct its national development."

18. Roger Fry (1866–1934) painting by the sea at Studland Bay, Dorset, 1911

In 1906, with the Rogers Fund in mind, J. Pierpont Morgan (1837–1913), the Museum's legendary fourth president, hired the British painter and connoisseur Roger Fry (1866–1934) to purchase pictures for the Museum. During the four or so years he worked for the Museum, first as a curator of paintings and then as a buying agent in Europe, Fry (Fig. 18) secured a highly uneven group of more than fifty works of all the European schools, mostly with moneys from the Rogers Fund.

Unfortunately, Roger Fry, who had a strong personal preference for the Italian school and for contemporary art, did not quite know what to make of seventeenth-century Dutch painting. After a buying trip to Holland in the summer of 1906, he wrote to a friend that he despaired "of ever understanding a School which produced so many minor masters with one work apiece and all about on the same level." Fry's best Dutch purchase was probably the fine, silvery *Calm Sea* by Simon de Vlieger (Fig. 19), and the Museum still owns *A Country Road* by Salomon van Ruysdael and *Portrait of a Woman* by Nicolaes Maes, both of

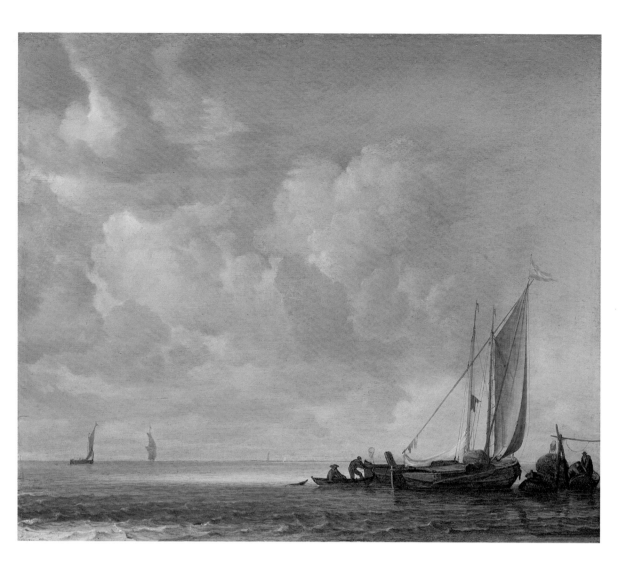

19. Simon de Vlieger (Dutch, ca. 1600/1601–1653). *Calm Sea*, ca. 1645–50. Oil on wood, 14¾ x 17½ in. (37.5 x 44.5 cm). Rogers Fund, 1906 (06.1200)

which he acquired in 1906. But not one of his Dutch acquisitions was quite as extraordinary as the Italian and modern paintings he bought, and a number of them have been deaccessioned over the years. To Fry's credit, however, he did propose to J. P. Morgan that the Museum buy one of Rembrandt's most celebrated paintings, the majestic *Self-Portrait* of 1658, from the Earl of Ilchester. Morgan initially told Fry he thought the Rembrandt too costly (at £30,000, or about $150,000). He later changed his mind, but his decision came too late: Fry had already contacted Henry Frick, who bought the *Self-Portrait* in 1906 for an inflated $225,000. The Ilchester Rembrandt, which Frick was kind enough to lend to the Museum for a few months in the summer of 1907 and again for the Hudson-Fulton Celebration in 1909 (see Fig. 28), remains one of the glories of the Frick Collection in New York.

In 1911 moneys from the Rogers Fund allowed John G. Johnson (1841–1917), the great Philadelphia collector of Dutch art, who was at the time a Museum trustee, to purchase *Skating at Sloten, Near Amsterdam* by Johannes Beerstraten in Amsterdam for the Metropolitan for 2,750 florins. In later years the Museum used the Rogers Fund mostly to fill in gaps in the collection and to finance (or partially finance) the purchase of such iconic works as Pieter Bruegel the Elder's

20. Alexandre Cabanel (French, 1823–1889). *Arabella (Yarrington) Worsham* (1850–1924), 1882. Oil on canvas, 85¼ x 50½ in. (216.5 x 128.3 cm). Fine Arts Museums of San Francisco, Gift of Archer M. Huntington (40.3.11). Arabella Worsham married Collis P. Huntington in 1884.

Harvesters (in 1919), Vincent van Gogh's *Sunflowers* (in 1949), and Georges de La Tour's *Fortune Teller* (in 1960). Over the course of the twentieth century the fund also allowed the Museum to buy a handful of seventeenth-century Dutch still lifes, among them an important *vanitas* by Pieter Claesz, *Still Life with a Skull and Writing Quill* (Fig. 59) in 1949; *Gamepiece with a Dead Heron ("Falconer's Bag")* by Jan Weenix, purchased in 1950; and *Still Life with Poppy, Insects, and Reptiles* by Otto Marseus van Schrieck, acquired in 1953. The Museum's Dutch collections also benefited from Jacob Rogers's generous gesture when the fund contributed to the acquisition of two history pieces: Godfried Schalcken's finely painted *Cephalus and Procris*, which came to the Museum in 1974, and Samuel van Hoogstraten's classicist *Annunciation of the Death of the Virgin* (Fig. 77), which was purchased in 1992. A rare Brazilian landscape by Frans Post (Fig. 72) was bought with Rogers Fund moneys in 1981. Today, the Museum continues to acquire works of art in Rogers's name.

While Roger Fry was acquiring paintings for the Museum in the first decade of the twentieth century, Arabella Huntington (Fig. 20) was building a remarkable collection of her own (see Fig. 21). After her husband Collis's demise in 1900, Arabella became one of the wealthiest women in the United States. From 1908 on, she worked closely with her late husband's nephew, the railroad magnate Henry E. Huntington (1850–1927), on the formation of the art collection that would eventually become part of the Henry E. Huntington Library and Art Gallery in San Marino, California. (The two were married in 1913.)

In 1907 Mrs. Huntington spent a total of about $2,500,000 for a number of pieces of furniture and several paintings from the Paris collection of Rodolphe Kann (1844/45–1905), a German-French mining magnate and banker who had assembled his pictures under the tutelage of Wilhelm Bode (see Fig. 14), the founder and director of the Kaiser-Friedrich-Museum in Berlin. In fact, Bode had expected to acquire Kann's Dutch pictures for his own museum, but because Kann died intestate the firm of Duveen Brothers was able to purchase from his estate what was perhaps the most admired private collection of seventeenth-century Dutch paintings of its day. Among the Kann pictures were "pieces of such importance and universal fame," the *Connoisseur* reported in 1908, that their departure from the Old World was "a calamity" for students and art lovers all over Europe. The acquisition of the Rodolphe Kann collection, for an astounding $4.5 million, was the first triumph of Joseph Duveen (1869–1939; Fig. 22), who in subsequent decades would continue to bring renowned old masters across the Atlantic. Ultimately, at least twenty-four Dutch paintings from the Rodolphe Kann collection would come to the Museum.

Among the paintings Arabella Huntington acquired through Duveen from the Kann collection were two late Rembrandts, *Hendrickje Stoffels* of 1660 (Fig. 23),

21. The library in the Huntington residence, 2 East Fifty-seventh Street, New York, 1919–25 (the house was built by George B. Post in 1890–92). The paintings, from left to right, are Sir Joshua Reynolds's *Lady Smith (Charlotte Delaval) and Her Children* of 1787, which Collis Huntington bought in 1895 and which came to the Museum in 1925 as part of his "1900 Bequest," and Rembrandt's *Hendrickje Stoffels, Aristotle with a Bust of Homer* (both previously in the Rodolphe Kann collection in Paris), and *Flora* (which was formerly with the Earls Spencer at Althorp and which Mrs. Huntington acquired in 1919).

22. William Reid Dick (Scottish, 1878–1961). *Joseph Duveen, Baron Duveen* (1869–1939), 1933. Stone bust, h. 27½ in. (69.9 cm). National Portrait Gallery, London. Given by the sitter's widow, 1939 (NPG 3062). Duveen, an exceptionally skilled salesman and a tireless self-promoter, quickly became one of the world's premier art dealers in the first decade of the twentieth century. According to his biographer S. N. Behrman, early in life Duveen noticed that "Europe had plenty of art and America had plenty of money, and his entire astonishing career was the product of that simple observation."

for which she paid $135,000, and *Aristotle with a Bust of Homer* (then known as *The Savant*) of 1653 (Fig. 24), for an unknown sum. *Aristotle with a Bust of Homer*, without doubt the pièce de résistance of the Kann collection, was then, as it is now, considered one of the world's great masterpieces of painting. It was commissioned by the great Sicilian collector Don Antonio Ruffo (1610/11–1678), Rembrandt's only foreign patron, who paid the artist his high asking price of 500 florins. Interestingly, the canvas was listed in Ruffo's 1654 inventory as a "half-length figure of a philosopher made in Amsterdam by the painter named Rembrant [*sic*] (it appears to be Aristotle or Albertus Magnus)." In the early 1660s Ruffo ordered two companion pieces from Rembrandt, an "Alexander the Great" (now lost) and *Homer* (Mauritshuis, The Hague). The *Aristotle* descended in the Ruffo family until at least the late eighteenth century. In 1810 the painting appeared in a London sale as "Portrait of a Sculptor with a Bust," by Rembrandt, fetching a price of £79.16. Later, it became part of the famed collection of the Earls Brownlow, from which it was sold to Rodolphe Kann in 1894.

Frans Hals's *Paulus Verschuur* of 1643 (Fig. 25), Rembrandt's *Hendrickje Stoffels*, and another prized Rembrandt portrait, *Flora* (Fig. 26), which Mrs. Huntington acquired in 1919, were among the paintings from her collection that her son, the renowned Hispanist Archer M. Huntington (1870–1955), gave to the Metropolitan Museum in 1926. *Aristotle with a Bust of Homer* would not become part of the Metropolitan's collection until thirty-five years later. After his mother's death, Archer Huntington kept the Rembrandt to hang in his own home. Two years later, however, he sold it back to Duveen Brothers, using the proceeds in the construction of the American Academy of Arts and Letters on

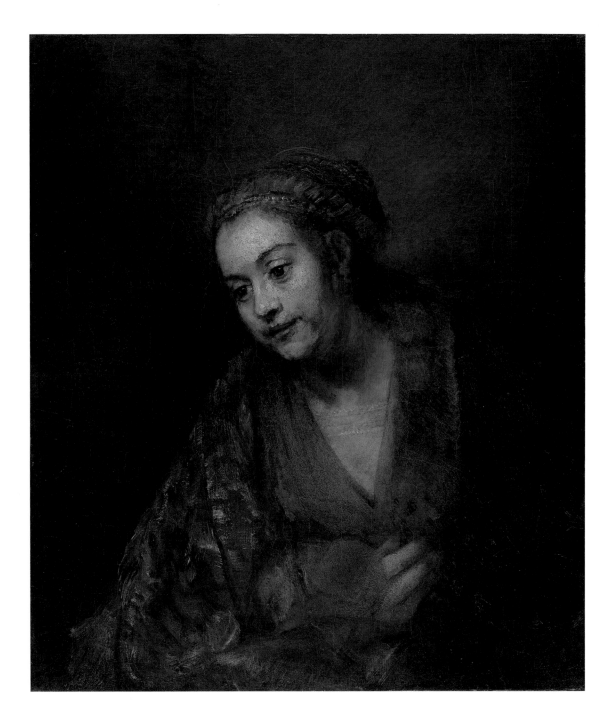

23. Rembrandt van Rijn (Dutch, 1606–1669). *Hendrickje Stoffels*, 1660. Oil on canvas, 30⅞ x 27⅛ in. (78.4 x 68.9 cm). Gift of Archer M. Huntington, in memory of his father, Collis Potter Huntington, 1926 (26.101.9). The woman portrayed here is probably Hendrickje Stoffels (ca. 1625/26–1663), whom Rembrandt hired as a maidservant in 1647 and who soon became his common-law wife. A daughter, Cornelia, was born to the couple in 1654, as a consequence of which Hendrickje was censured by the Calvinist Church.

Audubon Terrace, New York. Shortly after, on November 12, 1928, Joseph Duveen sold the *Aristotle* for $750,000 to the advertising tycoon Alfred Erickson (1876–1936), a member of New York's new generation of collectors, who owned a small but choice collection of old masters. After the 1929 Wall Street crash, Erickson was forced to sell the Rembrandt back to Duveen, who paid him $500,000 for it. Shortly before the collector died in 1936, he retrieved the *Aristotle* from Duveen, this time at a cost of $590,000. Erickson's widow, Anna, would keep the *Aristotle* in her possession until her death in 1961, when the Museum was able to purchase it with funds from several benefactors.

Long before it arrived in 1961, *Aristotle with a Bust of Homer* had been shown at the Metropolitan. In 1909, two years after Mrs. Huntington bought the painting,

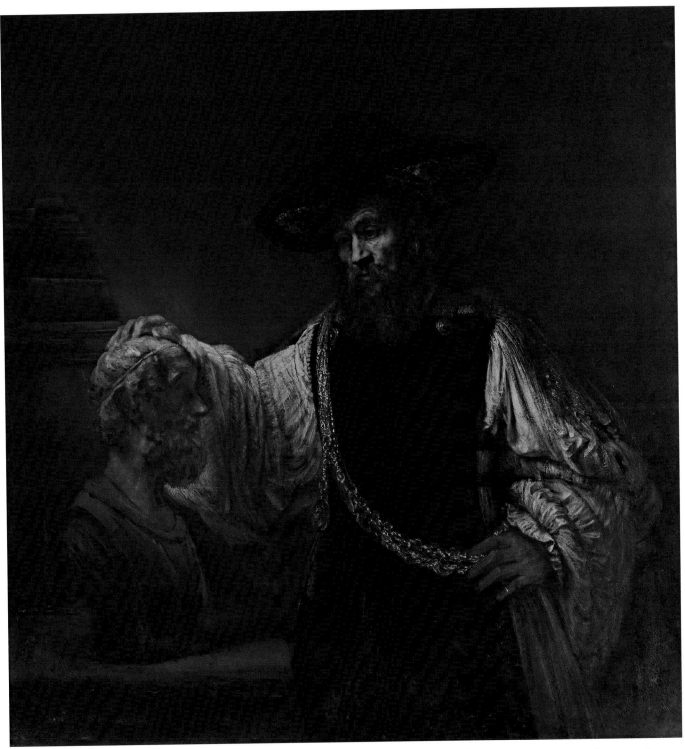

24. Rembrandt van Rijn (Dutch, 1606–1669). *Aristotle with a Bust of Homer*, 1653. Oil on canvas, 56½ x 53¾ in. (143.5 x 136.5 cm). Purchase, special contributions and funds given or bequeathed by friends of the Museum, 1961 (61.198). The Greek philosopher Aristotle, who wears a gold chain with a medallion depicting his pupil Alexander the Great, rests his hand on a bust of Homer, the venerated poet of earlier times.

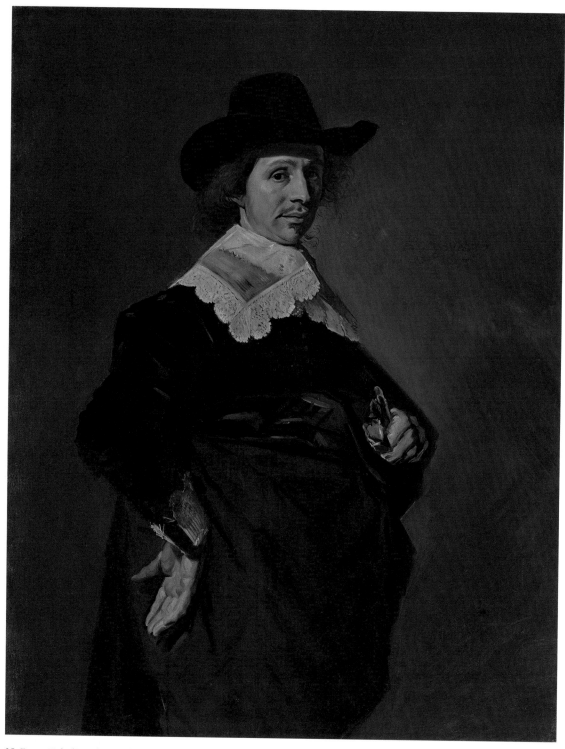

25. Frans Hals (Dutch, 1582/83–1666). *Paulus Verschuur*, 1643. Oil on canvas, 46¾ x 37 in. (118.7 x 94 cm). Gift of Archer M. Huntington, in memory of his father, Collis Potter Huntington, 1926 (26.101.11)

26. Rembrandt van Rijn (Dutch, 1606–1669). *Flora*, probably ca. 1654. Oil on canvas, 39⅜ x 36⅛ in. (100 x 91.8 cm). Gift of Archer M. Huntington, in memory of his father, Collis Potter Huntington, 1926 (26.101.10)

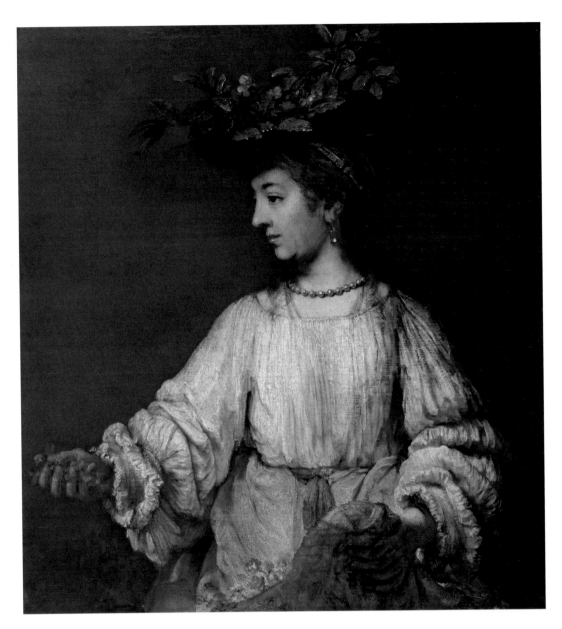

it was exhibited in America's first grand showcase of its holdings of Dutch art, the Hudson-Fulton Celebration (Figs. 27 and 28). The exhibition had two parts: The first was a display of Dutch paintings, furniture, and other art objects commemorating the tercentenary of Henry Hudson's exploration of the river that was named after him, a venture that was financed by the Dutch East India Company. The second included American paintings, furniture, and decorative arts and celebrated Robert Fulton's invention of the boat that introduced steam navigation to the Hudson River in 1807. One of the first blockbuster exhibitions in the United States, the Hudson-Fulton Celebration was organized by the Museum's new curator of decorative arts, twenty-nine-year-old Wilhelm (William) Valentiner (1880–1958), a German scholar of Dutch art and a protégé and former personal assistant of Wilhelm Bode's who would be a major influence on American collectors and museums for decades to come.

Almost all of America's great collectors of Dutch art lent some of their recent acquisitions to Valentiner's exhibition. J. P. Morgan, the Museum's president, lent the largest number of paintings, fifteen; Mrs. Huntington participated with eight works, including Rembrandt's *Aristotle*; Henry Frick contributed eight paintings as well (including the 1658 Rembrandt *Self-Portrait*); and Mrs. Havemeyer lent two of her Rembrandts, plus De Hooch's *Visit* (Fig. 13). In the nick of time, Benjamin Altman (see Fig. 29) also decided to contribute six of his new Dutch purchases, among them three Rembrandts and his Vermeer (Fig. 35). The Metropolitan Museum itself lent sixteen pictures, supposedly the cream of its still modest Dutch collections, including several works from the 1871 Purchase, such as Bartholomeus van der Helst's *Portrait of a Man* and Salomon van Ruysdael's *Drawing the Eel* (Fig. 2); a number of pictures from the Marquand bequests, among them three Hals portraits (see Fig. 9), Vermeer's *Young Woman with a Water Pitcher* (Fig. 8), and the two Marquand Rembrandts (see Fig. 7), still the only Rembrandts the Museum possessed. Some of Roger Fry's recent purchases, among them the De Vlieger seascape (Fig. 19), were included as well.

As successful as it was ambitious, the Hudson-Fulton exhibition drew 288,103 visitors in some two and a half months. Rembrandt was the show's undeniable star: of a total of 149 Dutch paintings on view, no fewer than 37 were attributed to Rembrandt (although by current standards they were a jumble of authentic and alleged works). According to Wilhelm Valentiner, who through his many contacts with scholars, collectors, and dealers on both sides of the Atlantic had an excellent sense of the most recent wanderings and whereabouts of Dutch pictures, the selection of the Rembrandts in the New York exhibition represented just over half of the 70 Rembrandts then in collections in the United States. The Hudson-Fulton Celebration also featured 21 works by Hals, 12 by Jacob van

27. The Hudson-Fulton Celebration, The Metropolitan Museum of Art, fall 1909. Third from left is Frans Hals's *Paulus Verschuur*, which was then in the possession of Arabella Huntington and came to the Metropolitan Museum in 1926. Fourth from right is another Frans Hals, the Marquand *Portrait of a Man*. Rembrandt's *Standard-Bearer (Floris Soop)* of 1654, at the time owned by the railroad executive George Jay Gould (1864–1923), is second from right; it was bought by Jules Bache in 1926, who bequeathed it to the Museum in 1949. On the far wall in the adjacent gallery, seen through the doorway, is Rembrandt's *Herman Doomer*, then owned by Mrs. Havemeyer.

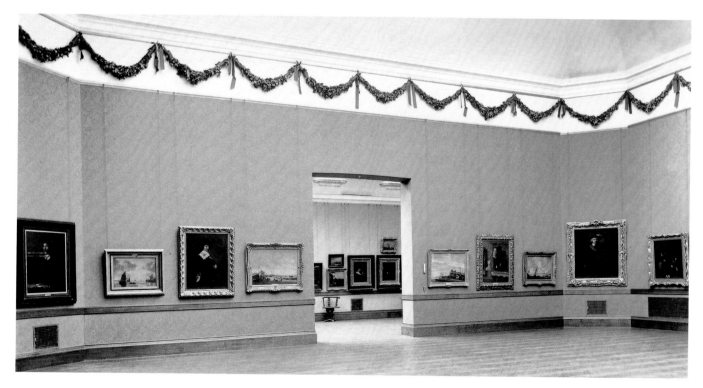

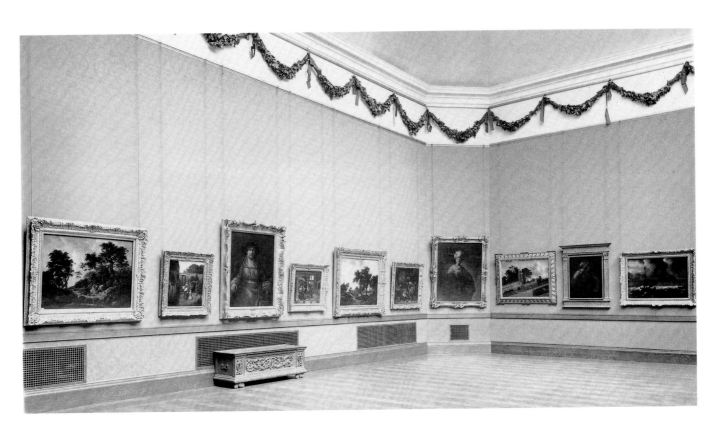

28. The Hudson-Fulton Celebration, The Metropolitan Museum of Art, fall 1909. Third from left is Rembrandt's *Self-Portrait* of 1658 (Frick Collection, New York), bought by Henry Clay Frick in 1906; fourth from right is Rembrandt's *Man in Oriental Costume* (then called *The Noble Slav*) of 1632, lent by William K. Vanderbilt, who left it to the Metropolitan Museum in 1920. Second from right is *The Sibyl*, then also thought to be by Rembrandt, which was owned by the Newport financier and Egyptologist Theodore M. Davis (1837–1915); now generally taken to be a work of about 1654–56 by Rembrandt's pupil Willem Drost, it came to the Museum in 1930.

Ruisdael, and 11 by Aelbert Cuyp, and an impressive 6 of the 7 Vermeers then owned by Americans.

"No such resplendent show has hitherto been made in this country and in all probability it will be many a year before anything like it is organized again," New York art critic Royal Cortissoz wrote in the *Tribune*. "These pictures throw, to begin with, a flood of light on Dutch types, Dutch manners and dress, boldly relieved against a background of Dutch landscape and architecture." Echoing the opinions of earlier critics like Théophile Thoré and Eugène Fromentin, Cortissoz noted that "in the portraits of Rembrandt and Hals you are brought face to face with the seventeenth-century burgher and his wife; Vermeer and De Hoogh will show you how they lived at home, and while the Ruisdaels expose the character of the countryside and waterways in Holland the broadly humorous compositions of Jan Steen will people the scene for you with Hobbinol and his doxy."

For another reviewer, the American artist Kenyon Cox, writing in the *Burlington Magazine*, the 1909 exhibition offered an occasion to reflect on the recent transfer of many of Europe's art treasures to the United States. However Europeans might be inclined to regard this trend, an American might "be pardoned for rejoicing at it," Cox said, noting that his countrymen should also celebrate the further fact that some of the best of these recent art imports had already become the property of public institutions, as it was probable that all would sooner or later be. Wilhelm Bode, who kept an exceptionally close watch on what had by now become a true exodus of Europe's artistic wealth, commented on the same phenomenon in a long article in the *New York Times* in 1911: "As the Americans almost without exception are under the conviction that one

29. Benjamin Altman (1840–1913)

day their collections will pass to the public galleries in the form of bequests, their ambition to erect in this way a monumentum aere perennius [monument more lasting than bronze] is indeed one of the noblest, and we Europeans have every reason to envy it in them."

Four years after its well-received Dutch paintings exhibition, the Museum's holdings of the Dutch school improved significantly when it received the magnificent bequest of Benjamin Altman (1840–1913), one of America's leading collectors of Dutch art. The son of Bavarian immigrants who came to New York in the mid-nineteenth century, Altman (Fig. 29) made his fortune with one of the world's great department stores, B. Altman and Co. Roland Knoedler, the prominent New York art dealer, described a meeting with the budding collector in 1904: "I called on him. He wanted to know what new things we were going to get. He does not think he will be interested in Dutch pictures but always repeats that he wants fine English works." At the time Altman's collection consisted

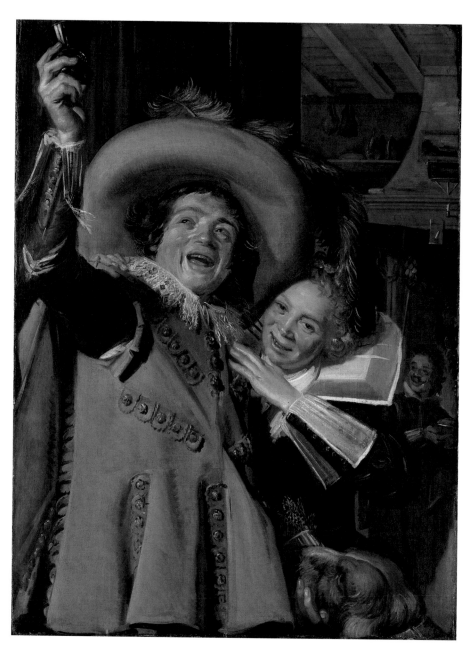

30. Frans Hals (Dutch, 1582/83–1666). *Young Man and Woman in an Inn ("Yonker Ramp and His Sweetheart")*, 1623. Oil on canvas, 41½ x 31¼ in. (105.4 x 79.4 cm). Bequest of Benjamin Altman, 1913 (14.40.602). Hals was one of the most sought-after artists in Gilded Age America. The traditional title of this early genre scene goes back to the eighteenth century and is based upon an incorrect identification of the male protagonist as Pieter Ramp, who appears in a 1627 group portrait by Hals.

31. Benjamin Altman's art gallery behind his town house at 626 Fifth Avenue, New York, 1913 or before. Hanging in the gallery, which was built in 1909, are Frans Hals, *Merrymakers at Shrovetide* of about 1616–17, which Altman bought in 1908 for $89,102; *Old Woman in an Armchair*, which he acquired in 1908 as a Rembrandt (but is currently catalogued as "Attributed to Jacob Backer"); Diego Velázquez, *Supper at Emmaus* of 1622–23, bought in 1910; *Old Woman Cutting Her Nails* of 1655–60, bought in 1908 for $148,535 as a Rembrandt (but at present labeled "Style of Rembrandt").

32. Benjamin Altman's art gallery behind his town house at 626 Fifth Avenue, New York, 1913 or before. On the left wall are seven of Altman's thirteen Rembrandts: *Man with a Magnifying Glass*, early 1660s, formerly with Maurice Kann, bought by Altman in 1909 for $262,980; *Pilate Washing His Hands*, probably also from the 1660s, previously with Rodolphe Kann, acquired in 1907 for $280,000 (now "Style of Rembrandt"); *Woman with a Pink*, the pendant of *Man with a Magnifying Glass*, which also cost $262,980 in 1909; *Portrait of a Man Holding Gloves* of 1648, from the Ashburton collection, bought in 1909 for $125,000; the oval *Portrait of a Woman*, 1633, formerly in Poland, purchased in 1909 for $60,000; *Portrait of a Man ("The Auctioneer")*, from the Maurice Kann collection, bought in 1909 for $262,980 (presently thought to be by a follower of Rembrandt); *Man with a Steel Gorget*, previously with a Berlin collector, bought in 1905 for $120,000 (now catalogued as "Style of Rembrandt"). The remaining paintings on the left wall are Aelbert Cuyp, *Young Herdsmen with Cows*; Johannes Vermeer, *A Maid Asleep*; Frans Hals, *Boy with a Lute*; and two small works that may be Gerrit Dou's *Self-Portrait* and Gerard ter Borch's *Woman Playing the Theorbo-Lute and a Cavalier*. On the end wall are Anthony van Dyck, *Lucas van Uffel*; a supposed Velázquez, *Philip IV*, now considered a workshop piece; and another Van Dyck, *Portrait of a Woman, Called the Marchesa Durazzo*.

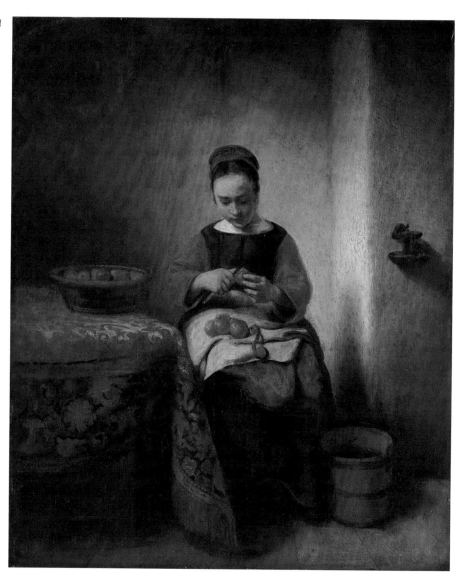

mostly of contemporary American and French paintings and decorative objects. Within a year, however, despite his apparent reservations, he had acquired two foremost Dutch pictures: an alleged Rembrandt, *Man with a Steel Gorget*, for $120,000, and a celebrated early genre scene by Frans Hals, *Young Man and Woman in an Inn* of 1623 (Fig. 30), for $155,840. Although the "Rembrandt" has since lost its great name and is currently thought to be the work of a member of the master's immediate circle in the 1640s, Altman's Hals has lived up to its early fame and remains a gallery favorite.

It took Altman less than eight years to amass his extraordinary collection of old masters, which included some twenty-four Dutch works (see Figs. 31 and 32). In January 1908 he bought (on one day) no fewer than eight Dutch paintings from the Rodolphe Kann collection: an excellent Cuyp; a De Hooch; a fine Hobbema; Maes's *Young Woman Peeling Apples* (Fig. 33); and three late (supposed) Rembrandts, among these *Old Woman Cutting Her Nails* of 1655–60 (Fig. 34), then a much coveted work. In addition, Altman acquired Kann's early Vermeer, *A Maid Asleep* of about 1656–57 (Fig. 35).

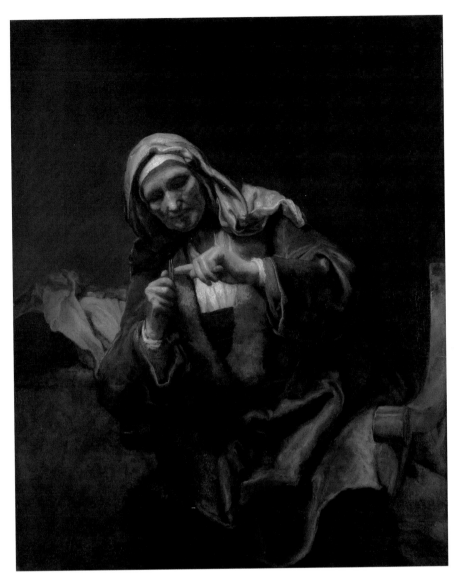

"The greatest treasure for an American collector is a painting by Vermeer of Delft," Wilhelm Bode wrote in the *New York Times* in 1911, arguing that the master's popularity was in part due to his feeling for light and color, so close "to our modern feeling," and in part to the rarity of his paintings. Mostly thanks to the high prices they were willing to pay, American collectors succeeded in acquiring no fewer than eight autograph Vermeers (plus a few spurious ones) before the outbreak of World War I.

Without doubt, however, it was Rembrandt who was Altman's great favorite, and Joseph Duveen, his main dealer, happily supplied him with a number of the master's paintings that had recently come on the market. In 1909 Altman was able to purchase through Duveen several important works from the collection of Rodolphe Kann's brother, Maurice Kann (d. 1906), also a noted Paris collector, including the impressive Rembrandt pendants *Man with a Magnifying Glass* and *Woman*

34. Style of Rembrandt. *Old Woman Cutting Her Nails*, 1655–60. Oil on canvas, 49⅝ x 40⅛ in. (126.1 x 101.9 cm). Bequest of Benjamin Altman, 1913 (14.40.609). Celebrated as by Rembrandt in the early twentieth century, this painting was praised by Wilhelm Bode and his contemporaries for its noble depiction of a humble subject. The work was removed from Rembrandt's oeuvre in the 1930s, but its authorship has remained subject to debate. A likely candidate is the Dordrecht painter Abraham van Dijck (ca. 1635?–?1680).

with a Pink of the early 1660s and a beautiful Jacob van Ruisdael, *Wheatfields* of about 1670 (Fig. 36). That same year Altman bought Rembrandt's famed *Self-Portrait* of 1660 (Fig. 37). "[T]hat horrible old Altman seems to gobble up most of the best things these days," Mary Berenson, wife of the connoisseur and picture agent Bernard Berenson, wrote to her husband's chief patron, Isabella Stewart Gardner of Boston, in 1913.

Some four months before his death in 1913 Altman made his last major purchase when he bought the last of his thirteen Rembrandts, *The Toilet of Bathsheba* of 1643 (Fig. 38). The painting was being offered for sale in Paris by the descendants of Baron Steengracht van Oosterland of The Hague, who had had it in his possession by 1859. "The Steengracht *Bathsheba* is really an exceptionally fine picture by Rembrandt and in excellent state," Wilhelm Bode, one of Altman's main competitors for old masters, wrote to Henry Duveen (1854–1918), Joseph's uncle, in May of 1913. "I should like to be able to buy the picture for our Museum [in Berlin] but where [to] get the money?!" Henry Duveen bid on *The Toilet of Bathsheba* on behalf of Altman at the Steengracht sale on June 9, 1913, and

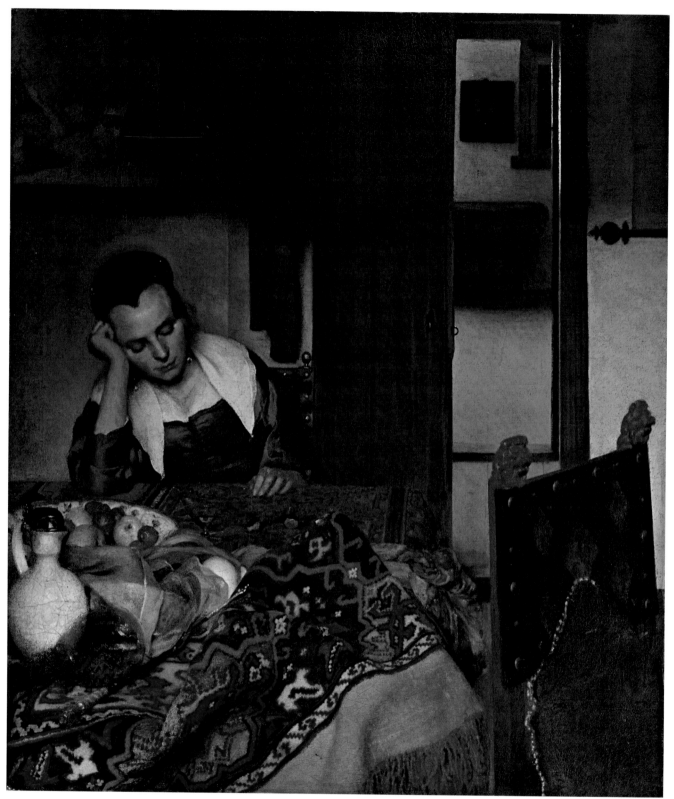

35. Johannes Vermeer (Dutch, 1632–1675). *A Maid Asleep*, ca. 1656–57. Oil on canvas, 34½ x 30⅛ in. (87.6 x 76.5 cm). Bequest of Benjamin Altman, 1913 (14.40.611). A crucial early work in Vermeer's oeuvre, this canvas was executed at a time when the master was still experimenting with composition and technique. X-rays indicate that he initially included a dog in the doorway and a man in the distant room and later painted them out. The picture was possibly the first Vermeer acquisition of the wealthy Delft collector Pieter van Ruijven (1624–1674), the artist's primary patron. In 1696 it was part of the Amsterdam auction of works from the estate of Van Ruijven's son-in-law and heir, Jacob Dissius (1653–1695). According to a contemporary newspaper announcement, the Dissius sale consisted of "several outstandingly artful paintings, including twenty-one works most powerfully and splendidly painted by the late J. Vermeer of Delft." Listed in the sale catalogue as "A drunken, sleeping young Woman [or maid] at a Table," the Altman Vermeer sold for a modest 62 guilders.

36. Jacob van Ruisdael (Dutch, 1628/29–1682). *Wheatfields*, ca. 1670. Oil on canvas, 39⅜ x 51¼ in. (100 x 130.2 cm). Bequest of Benjamin Altman, 1913 (14.40.623)

secured it for 1,000,000 francs (about $200,000), a new record in the auction rooms, as the international newspapers eagerly reported (see Fig. 39). After Altman had heard the good news, he sent his middleman a cable: "MANY THANKS VERY HAPPY KINDEST REGARDS TO ALL ALTMAN."

Days after Altman's death on October 7, 1913, it was announced that he had bequeathed his collection—with its thirteen assumed and authentic Rembrandts, three Halses, a Van Ruisdael, a Vermeer, and many other treasures—to the Metropolitan Museum. The department store magnate left more Dutch paintings to the institution than any other collector before or after him (see Fig. 40). As one of the trustees wrote at the time, the Museum was now "in the forefront of the world's treasure houses, with the Louvre and Madrid."

Altman's death, and the deaths of several other important collectors in the 1910s—J. P. Morgan (also in 1913), P. A. B. Widener (in 1915), John G. Johnson (in 1917), and Henry Frick (in 1919) among them—changed significantly the nature of collecting in the United States. Of course other factors contributed as well, chiefly the establishment of a federal income tax in 1913 and the outbreak of World War I, which all but paralyzed the art trade.

Although somewhat less coveted than before, seventeenth-century Dutch art did not fall out of favor in the postwar years. A number of bequests that included Dutch paintings, not all of which can be mentioned here, came to the Museum in the later 1910s and 1920s. In 1917 the Museum was given three Dutch paintings

37. Rembrandt van Rijn (Dutch, 1606–1669). *Self-Portrait*, 1660. Oil on canvas, 31⅝ x 26½ in. (80.3 x 67.3 cm). Bequest of Benjamin Altman, 1913 (14.40.618). Rembrandt's self-portraits are among the finest and most beloved works of his oeuvre. Approximately forty self-portraits by Rembrandt, dating from the late 1620s to 1669, are known today. Reliably signed "Rembrandt/f 1660" (at the lower right), this canvas was one of six Rembrandts in the renowned collection of the British Barons Ashburton, which was sold as a whole in 1907. Many of the Ashburton paintings found a permanent home in the United States.

38. Rembrandt van Rijn (Dutch, 1606–1669). *The Toilet of Bathsheba*, 1643. Oil on wood, 22½ x 30 in. (57.2 x 76.2 cm). Bequest of Benjamin Altman, 1913 (14.40.651). Prompted by works such as this one, the Dutch poet Andries Pels (1631–1681) noted in 1681 that Rembrandt "chose no Greek Venus as his model," but turned toward nature instead. The finely painted Old Testament scene was long considered one of Rembrandt's greatest paintings. British portraitist Sir Thomas Lawrence (1769–1830) owned it at the time of his death.

from the J. P. Morgan estate: a landscape by Aert van der Neer and two delicate genre scenes that had come from the Rodolphe Kann collection, Gerard ter Borch's *Young Woman at Her Toilet with a Maid* (Fig. 41) and Gabriël Metsu's *Visit to the Nursery* (Fig. 42), which Morgan had bought from Duveen for the substantial sums of £12,500 and £31,000 ($62,000 and $155,000), respectively. Several of Morgan's finest Dutch treasures unfortunately did not come to the Museum: his great early Rembrandt, *Nicolaes Ruts*, is now in the Frick Collection; his Vermeer, *A Lady Writing*, ultimately went to the National Gallery of Art, Washington, D.C.; and his celebrated Hals pendants, *De Heer Bodolphe* and *Mevrouw Bodolphe*, are now in the Yale University Art Gallery, New Haven.

Also in 1917 the Museum received a bequest of works of art and funds for additional acquisitions from the New York banker and railroad investor Isaac D. Fletcher (d. 1917). Fletcher's pictures included a small *Head of Christ*, previously with Maurice Kann, that was then thought to be a Rembrandt and is now attributed to a pupil. Some forty years later the Museum used the Fletcher Fund to buy a boisterous, late Steen, *Merry Company on a Terrace* of about 1670 (Fig. 43). (The Museum's purchase in 1971 of a splendid Velázquez, *Juan de Pareja*, was also principally financed with moneys from the Fletcher Fund.) Another important bequest, that of the railroad heir William K. Vanderbilt (1849–1920), came to the Museum in 1920. In addition to an early marine by Willem van de

39. "Auction Downstairs." Cartoon published in *De Amsterdammer*, a Dutch weekly, after Rembrandt's *Toilet of Bathsheba* had fetched a record price of one million francs at the Steengracht sale in Paris, June 9, 1913. The caption reads (in Dutch): "Satisfied, Rembrandt? . . . You are now a millionaire . . . !"

Velde the Younger (Fig. 44), Vanderbilt gave the Museum a major early Rembrandt, *Man in Oriental Costume ("The Noble Slav")* of 1632 (Fig. 45, and see Fig. 28). Several great collections (or parts of them) of the previous generation came to the Museum in the late 1920s, including Collis and Arabella Huntington's pictures in 1925 and 1926 and the Havemeyer paintings in 1929. In 1927 Samuel H. Kress (1863–1955), owner of a chain of department stores and Duveen's best client for Italian pictures, gave the Museum a single Dutch work, the large and colorful *Peacocks* (Fig. 46), painted in 1683 by Melchior d'Hondecoeter.

An impressive group of Dutch paintings arrived at the Museum in 1931 as part of a group of some 150 pictures bequeathed by Michael Friedsam (1858–1931), Benjamin Altman's close friend and his successor at B. Altman and Co. According to a *New York Times* headline, the collection Friedsam (Fig. 47) had amassed, which in addition to a number of Dutch and Flemish masterpieces (see Fig. 48) included several important "primitive" Italian works, was valued at $10,000,000. Friedsam enriched the Metropolitan's holdings with an excellent Jacob van Ruisdael, *Grainfields* of about 1665–69 (once owned by Sir Joshua Reynolds); a

40. The Dutch Room in the Altman Galleries in the Metropolitan Museum as it looks today, with a view of six of Benjamin Altman's Rembrandts. From left to right are the *Self-Portrait*, *The Toilet of Bathsheba*, the oval *Portrait of a Woman*, and the pendants *Man with a Magnifying Glass* and *Woman with a Pink*, all of which are still considered autograph Rembrandts. To the right is *Portrait of a Man ("The Auctioneer")*, now catalogued as "Style of Rembrandt."

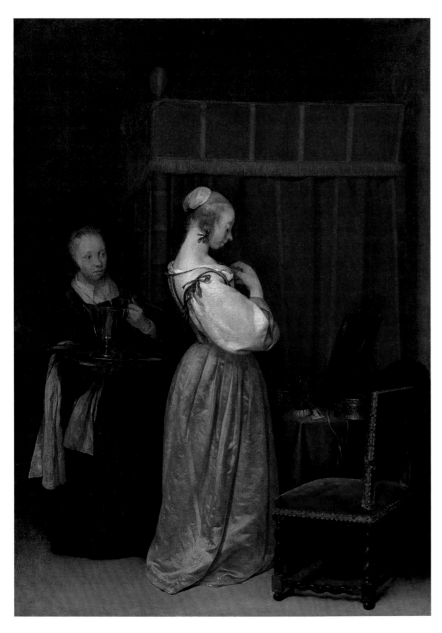

41. Gerard ter Borch (Dutch, 1617–1681). *A Young Woman at Her Toilet with a Maid*, ca. 1650–51. Oil on wood, 18¾ x 13⅝ in. (47.5 x 34.5 cm). Gift of J. Pierpont Morgan, 1917 (17.190.10)

fine piece by Eglon van der Neer (Fig. 49); a major equestrian portrait by Aelbert Cuyp (Fig. 50); and a somewhat atypical early Rembrandt, *Bellona* of 1633 (Fig. 51). In addition, the Friedsam bequest brought the Museum its fourth Vermeer, the enigmatic *Allegory of the Catholic Faith* of about 1670–72 (Fig. 52). Abraham Bredius (1855–1946), one of the first great scholars of Dutch art, purchased this *Allegory* in 1899 from a Berlin dealer as a work by Eglon van der Neer (see Fig. 49), an artist who was more esteemed in previous decades. Bredius, at the time director of the Mauritshuis at The Hague as well as one of Holland's chief private collectors of seventeenth-century Dutch paintings, recognized the painting as a lost Vermeer when he first laid eyes on it: "I looked at it and saw at once—from one thing and another—that it must be a Vermeer." Ironically, though, he never took a true liking to his rare find, which he described as "a large yet very awkward Vermeer."

In December 1911 Bredius offered his unusual *Allegory* to the great American collector J. P. Morgan. By 1911 prices for Vermeer's paintings had reached a record high in the United States: in January P. A. B. Widener of Philadelphia paid $115,000 (and exchanged four paintings) for the master's recently discovered *Woman Holding a Balance* (National Gallery of Art, Washington, D.C.), and later that year Henry Frick paid $225,000 for *Officer and Laughing Girl* (Frick Collection, New York), his second Vermeer. Bredius's asking price for the *Allegory*, if he had one in mind, is not known. Morgan was not interested in the painting, however. "He already has a very fine Vermeer, as you know . . . and does not particularly like the one belonging to Dr. Bredius," Morgan's librarian curtly informed Bredius's intermediary. The *Allegory* had cost little when Bredius bought it in 1899, less than 700 German marks. Three decades later, in 1928, Michael Friedsam acquired it from him through a dealer for a sizable $300,000.

Much like Benjamin Altman some two decades earlier, in the 1920s New York stockbroker Jules Bache (1861–1944) set out expressly to build a collection of masterpieces and relied heavily on the dealer Joseph Duveen (see Fig. 22), with mixed success. Bache (Fig. 53), as his acquaintance Louis S. Levy wrote shortly

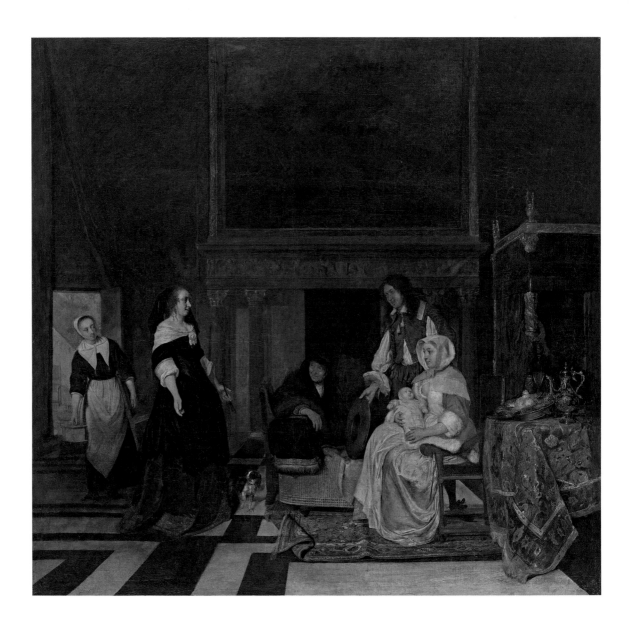

42. Gabriël Metsu (Dutch, 1629–1667).
The Visit to the Nursery, 1661. Oil on canvas,
30½ x 32 in. (77.5 x 81.3 cm). Gift of
J. Pierpont Morgan, 1917 (17.190.20)

after his death, was "a man of quick decisions and definite opinions, who respected any man who was a master of his craft." Captivated by Duveen's "extraordinary taste" and "broad knowledge," Bache grew "by leaps and bounds" as a collector under his dealer's guidance, purchasing more than ten and a half million dollars' worth of art from Duveen as paintings of all the major European schools "marched proudly and rapidly into his home." In 1930, in an article on Bache's already impressive yet still growing assembly of masterpieces, the critic Royal Cortissoz noted that it was impossible to approach the collection without thinking, in the first place, of what he called its "historical aspect." Not only were the Bache pictures important in themselves, but, what was more, they stood "amongst the landmarks in the evolution of our aesthetic culture." One of the most arresting things about the Bache paintings was their mere presence in this country; indeed, Cortissoz wrote, they awakened "fairly exciting thoughts on what American connoisseurship has achieved in the incredibly short time of half a century—or even less."

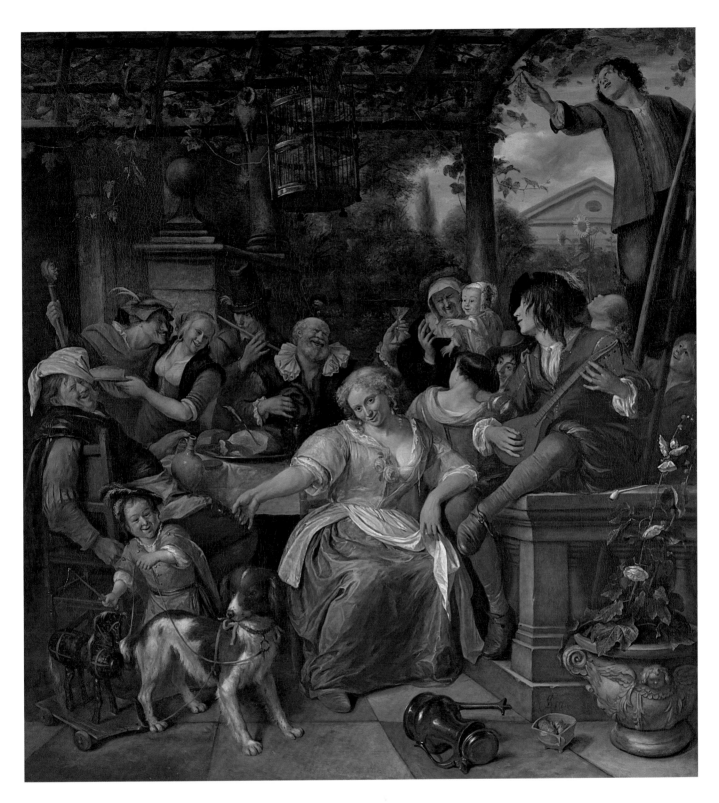

43. Jan Steen (Dutch, 1626–1679). *Merry Company on a Terrace*, probably ca. 1670. Oil on canvas, 55½ x 51¾ in. (141 x 131.4 cm). Fletcher Fund, 1958 (58.89)

Bache apparently bought pictures "solely for his own gratification and pleasure" and never entertained the thought of giving his collection to the public until Duveen "cleverly and effectively" steered him in that direction, according to Levy. As a result, in 1949, five years after Bache's death, the Museum was presented with more than sixty old masters from his collection, including several significant Dutch pictures. One of these was the famed *Standard-Bearer (Floris Soop)*

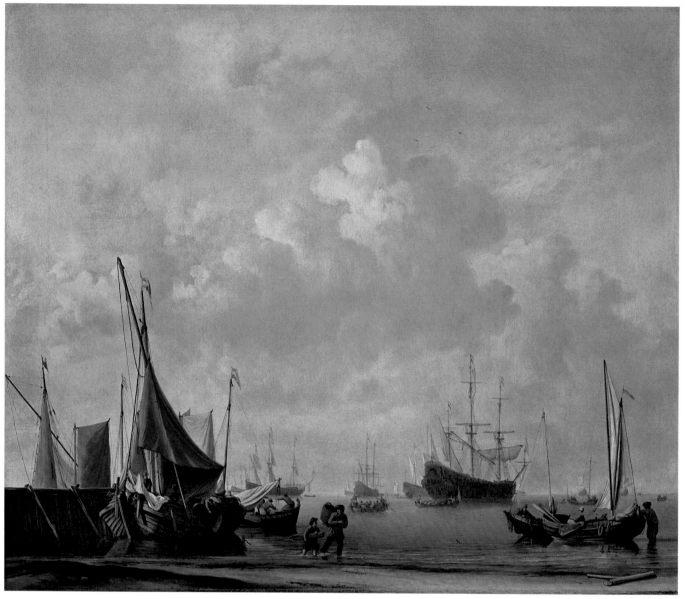

44. Willem van de Velde the Younger (Dutch, 1633–1707). *Entrance to a Dutch Port*, ca. 1665. Oil on canvas, 25⅞ x 30⅝ in. (65.7 x 77.8 cm). Bequest of William K. Vanderbilt, 1920 (20.155.6)

of 1654, which is still generally accepted as an autograph Rembrandt. In 1926 Bache had paid Duveen $257,805.91 for the painting, which had also once been in the collection of Sir Joshua Reynolds. Gerard ter Borch's *Curiosity* of about 1660–62 (Fig. 54), for which Bache paid $175,000 in 1927, and Frans Hals's *Portrait of a Man* of about 1636–38 (Fig. 55), for which he paid a steep $350,000 in 1928, were also part of the Bache bequest.

Bache's gift to the Museum also included two "Rembrandts" that have since lost their attribution to the master, as well as two alleged Vermeers. His first supposed Vermeer purchase took place in 1925, when he bought a *Portrait of a Young Boy* from Duveen for $175,000. Two years previously Joseph Duveen

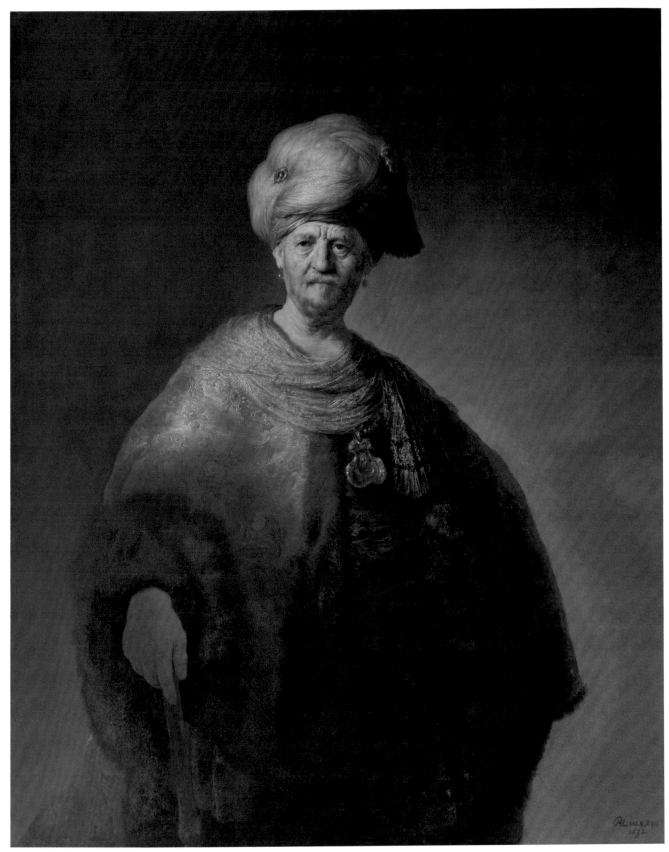

45. Rembrandt van Rijn (Dutch, 1606–1669). *Man in Oriental Costume ("The Noble Slav")*, 1632. Oil on canvas, 60⅛ x 43¾ in. (152.7 x 111.1 cm). Bequest of William K. Vanderbilt, 1920 (20.155.2)

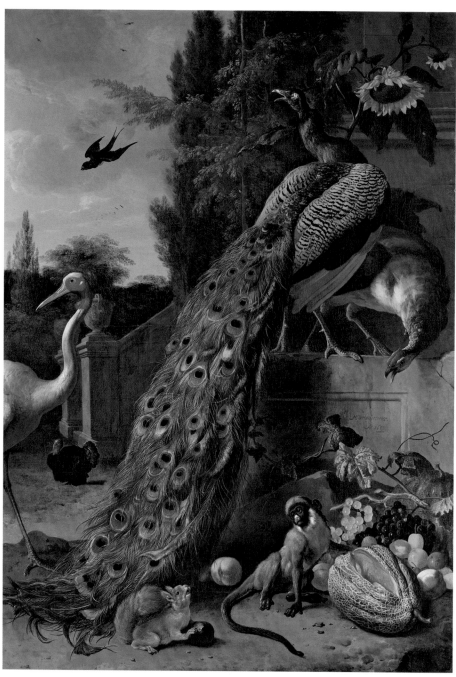

46. Melchior d'Hondecoeter (Dutch, 1636–1695). *Peacocks*, 1683. Oil on canvas, 74⅞ x 53 in. (190.2 x 134.6 cm). Gift of Samuel H. Kress, 1927 (27.250.1)

47. Michael Friedsam (1858–1931)

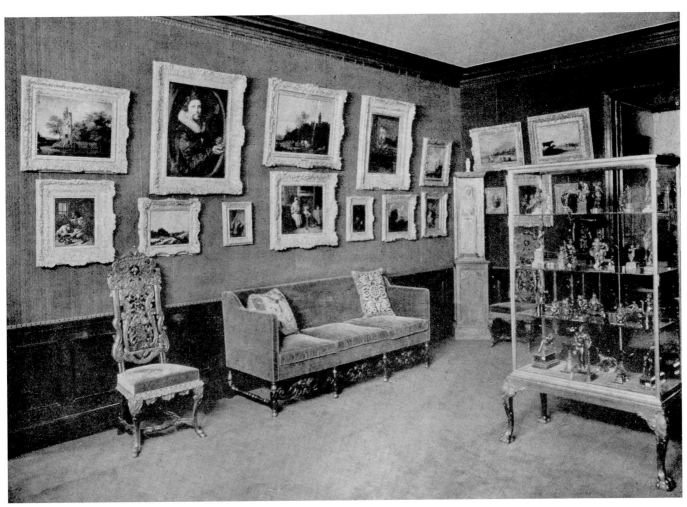

48. The Dutch side of the Dutch and Flemish room in Michael Friedsam's residence in New York, ca. 1916–17. In the center, above the couch, is Nicolaes Maes's *Lacemaker*, which Friedsam bought from Kleinberger Galleries for $27,500; above it is Anthonie van Borssom's *Barnyard Scene*, which he acquired as a Paulus Potter from Duveen in 1915 for $3,300. Both are in the Museum's collection. A contemporary caption also lists works by Hobbema, Steen, Hals, Wynants, Brouwer, Van Dyck, Van Ostade, Ruysdael, Van Goyen, Ter Borch, and others, as well as "a French XIV Century marble: Virgin teaching St Anne to read, and in the case, the collection of early Italian bronzes."

49. Eglon van der Neer (Dutch, 1635/36–1703). *The Reader*. Oil on canvas, 15 x 11 in. (38.1 x 27.9 cm). The Friedsam Collection, Bequest of Michael Friedsam, 1931 (32.100.9)

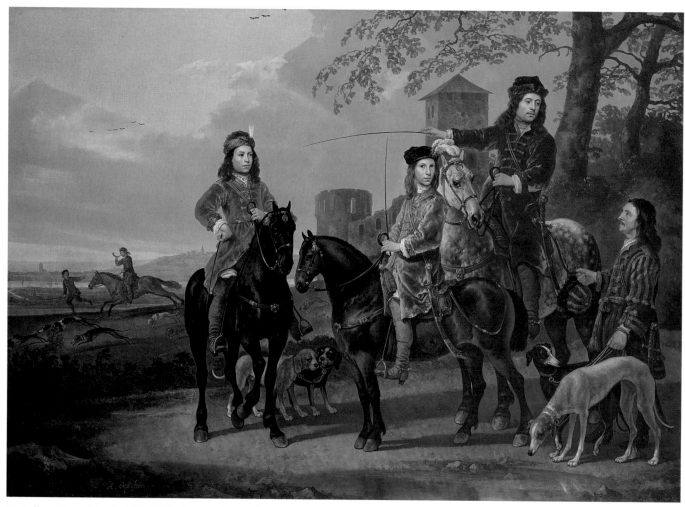

50. Aelbert Cuyp (Dutch, 1620–1691). *Equestrian Portrait of Cornelis and Michiel Pompe van Meerdervoort with Their Tutor and Coachman ("Starting for the Hunt")*, before 1653. Oil on canvas, 43¼ x 61½ in. (109.9 x 156.2 cm). The Friedsam Collection, Bequest of Michael Friedsam, 1931 (32.100.20). Cuyp, one of the great landscapists of the Dutch Golden Age, occasionally also painted portraits, mostly of members of the upper classes of his native Dordrecht. According to family inventories this painting depicts the two young sons of the wealthy Pompe van Meerdervoort family, Michiel (1638–1653) and Cornelis (1639–1680), with their tutor, Caulier, and their coachman, Willem. One of the artist's most impressive portraits, it remained with the family until the early nineteenth century. By 1895, when the picture was offered at a London sale, the sitters' identities had been forgotten, and its subject was listed as "The Prince of Orange, with his sons, prepared to depart for the chase."

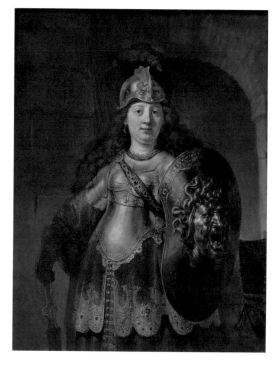

51. Rembrandt van Rijn (Dutch, 1606–1669). *Bellona*, 1633. Oil on canvas, 50 x 38⅜ in. (127 x 97.5 cm). The Friedsam Collection, Bequest of Michael Friedsam, 1931 (32.100.23). The Roman goddess of war bears a slight resemblance to Saskia van Uylenburgh (1612–1642), who became Rembrandt's wife in June 1634. In the late eighteenth century the painting was recommended to the first Marquess of Buckingham by Sir Joshua Reynolds, a great admirer of Rembrandt.

52. Johannes Vermeer (Dutch, 1632–1675). *Allegory of the Catholic Faith*, ca. 1670–72. Oil on canvas, 45 x 35 in. (114.3 x 88.9 cm). The Friedsam Collection, Bequest of Michael Friedsam, 1931 (32.100.18). One of two known allegories by Vermeer, this picture was probably painted for a private Catholic patron or for a "hidden" Catholic church. (Vermeer, the son of two Reformed Protestants, had converted to Catholicism before his marriage to Catherine Bolnes in 1653.)

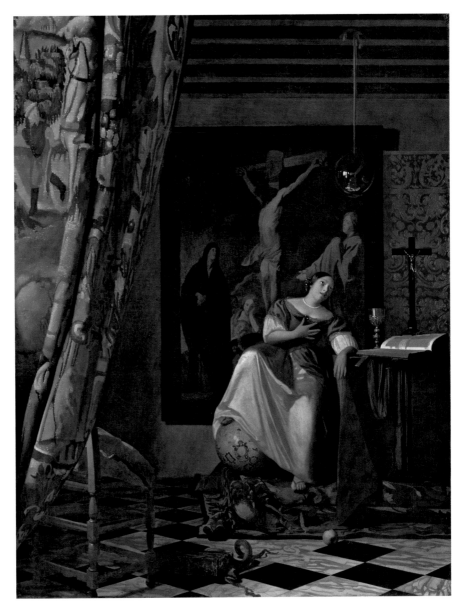

53. Jules Bache (1861–1944), ca. 1898

himself had paid the picture's French owner a substantial 750,000 francs. Bache was "especially elated" to add the Vermeer to his collection, Louis Levy later wrote. "He believed that a Vermeer in itself lifted his collection to a higher plane." Although the portrait's attribution to Vermeer had earlier been questioned, it came to Bache with the seal of approval of various experts, among them the eminent Dutch scholar Cornelis Hofstede de Groot (1863–1930). At present, however, it is attributed to one of Vermeer's French contemporaries, Sébastien Bourdon (1616–1671).

In 1928—a "banner year" for the Bache Collection and the "high tide" of the Duveen sales, according to Louis Levy—Bache acquired his second so-called Vermeer, the tiny *Young Woman Reading* (Fig. 56), from the dealer Wildenstein for $134,800. Little was known of the history of the painting, which had reportedly been discovered by the art historian Vitale Bloch in the collection of a physician

54. Gerard ter Borch (Dutch, 1617–1681). *Curiosity*, probably ca. 1660–62. Oil on canvas, 30 x 24½ in. (76.3 x 62.3 cm). The Jules Bache Collection, 1949 (49.7.38). The traditional title of this fine genre piece probably dates to the early nineteenth century. Ter Borch's half sister Gesina (1631–1690), an artist and an amateur poet, likely served as a model for the curious young woman. She also appears in Ter Borch's *A Young Woman at Her Toilet with a Maid* (Fig. 41).

at The Hague. It, too, had been authenticated by several reputable experts of Dutch painting, chief among them Wilhelm Bode and, again, Cornelis Hofstede de Groot. Still, the costly alleged Vermeer turned out to be an outright modern fake; it had probably been painted shortly before its 1928 sale to Bache, perhaps even expressly for the overheated American market for Vermeer. Both of Bache's "Vermeers," although never on view, have been retained by the Museum to this day, silent reminders that America's taste for the sought-after Dutch master did not always bring fortunate results.

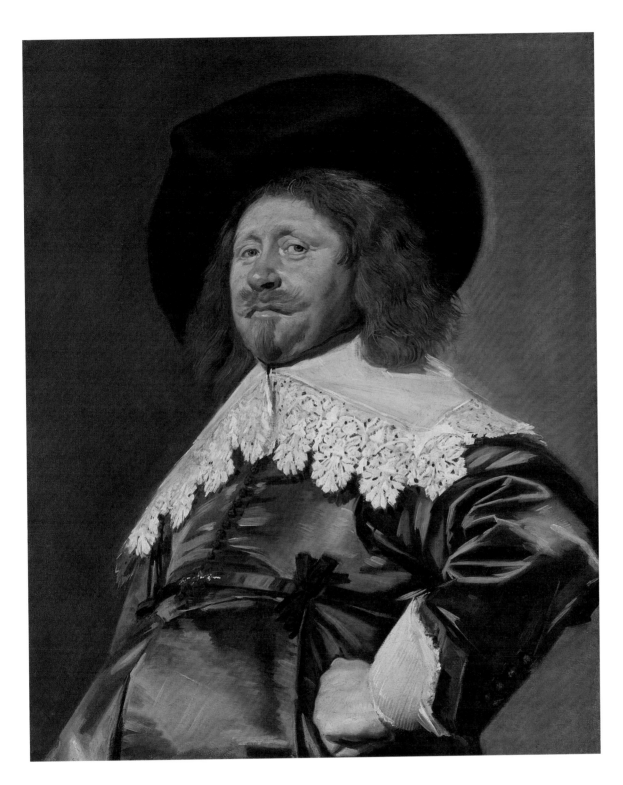

55. Frans Hals (Dutch, 1582/83–1666).
Portrait of a Man, Possibly Nicolaes Pietersz Duyst van Voorhout, ca. 1636–38. Oil on canvas, 31¾ x 26 in. (80.6 x 66 cm). The Jules Bache Collection, 1949 (49.7.33)

Another important early Rembrandt, *Portrait of a Young Woman with a Fan* of 1633 (Fig. 57), and a large allegory by the classicist Gerard de Lairesse, *Apollo and Aurora* of 1671 (Fig. 58), were among the handful of Dutch pictures given to the Museum in the early 1940s. The Museum's holdings of Dutch art continued to grow in the decades after World War II, but at a more deliberate pace than in earlier decades. Endowed funds as well as the support of private individuals allowed for acquisitions ranging from the modest to the extraordinary. Several lacunae in the collection were filled as a series of still lifes were added at the

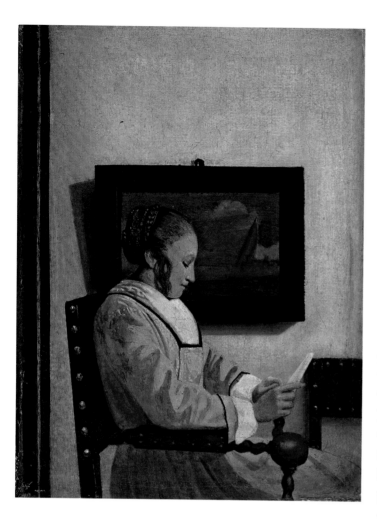

56. Imitator of Johannes Vermeer. *A Young Woman Reading*, ca. 1925–27. Oil on canvas, 7¾ x 5¾ in. (19.7 x 14.6 cm). The Jules Bache Collection, 1949 (49.7.40)

initiative of curator Theodore Rousseau (1912–1973), who started his twenty-seven-year career at the Museum in the Department of European Paintings in 1946 and later became curator-in-chief and vice-director. Pieter Claesz's unusually well-preserved *Still Life with a Skull and Writing Quill* of 1628 (Fig. 59) was bought in 1949; Jan Weenix's *Gamepiece with a Dead Heron ("Falconer's Bag")* followed in 1950; and Otto Marseus van Schrieck's *Still Life with Poppy, Insects, and Reptiles* was purchased in 1953, all three with support from the Rogers Fund. Willem Kalf's *Still Life with Fruit, Glassware, and a Wanli Bowl* of 1659 was also bought in 1953, with support from the DeWitt Jesup Fund.

A key acquisition of a different kind followed in 1956, when the Museum purchased a magnificent painting by the Utrecht Caravaggist Hendrick ter Brugghen, *The Crucifixion with the Virgin and Saint John* of about 1624–25 (Fig. 60). Painted most likely as an altarpiece for a private chapel or for a "hidden" Catholic church, Ter Brugghen's arresting canvas calls to mind the work of such earlier artists as Albrecht Dürer (1471–1528) and Matthias Grünewald (1475/80–1528). Nothing is known about its early provenance, but for at least eighty years, from the late nineteenth to the mid-twentieth century, it hung in a side chapel of Christ Church, a small Victorian church in South Hackney, London, together with a copy of Peter Paul Rubens's *Deposition*. Looking "rather grimy" at the time and without a label, Ter Brugghen's altarpiece was thought to be a work by the school of Carracci, according to Nigel Foxell, the son of Christ Church's last vicar. (Evidently, no one was then aware of Ter Brugghen's monogram—*HTB*—which is now visible on the bottom of the cross, a little above the skull.) Christ Church was bombed in World War II, and after it was deconsecrated and demolished in 1955 the Ter Brugghen and the Rubens copy were transferred to Saint John's, a larger church nearby. When Foxell stopped by not long after, eager to learn what Saint John's—a "flagship of Protestantism"—had done with the two "popish" paintings from his father's church, he found them lying face upward on the flat roof of a vestry inserted into the church's nave. Although some plaster had fallen on the paintings, they seemed undamaged, and Foxell offered the rector of Saint John's the small sum of £80 for *The Crucifixion with the Virgin and Saint John*.

In the fall of 1956, after a Sotheby's employee had finally recognized it as a Ter Brugghen, Foxell sold the *Crucifixion* at auction in London. The canvas was bought for the Metropolitan Museum by the New York dealer Harry Sperling for a considerable £15,000. (Foxell donated his profit to the Diocese of London.)

57. Rembrandt van Rijn (Dutch, 1606–1669). *Portrait of a Young Woman with a Fan,* 1633. Oil on canvas, 49½ x 39¾ in. (125.7 x 101 cm). Gift of Helen Swift Neilson, 1943 (43.125)

58. Gerard de Lairesse (Dutch, 1641–1711).
Apollo and Aurora, 1671. Oil on canvas,
80½ x 76⅛ in. (204.5 x 193.4 cm). Gift of
Manuel E. and Ellen G. Rionda, 1943
(43.118)

"From a bombed church in the East End of London, through Sotheby's auction rooms, where it caused excitement among museum directors from both sides of the ocean, a painting of unusual importance, hitherto unknown, has recently come to the Metropolitan Museum," the Museum's *Bulletin* triumphantly announced. Ter Brugghen, as the *Bulletin* noted, had always remained "an outsider between countries, an individualist between styles." Although the influence of this Utrecht Caravaggist on the following generation of Dutch artists was minor, "his understanding of humanity and his feeling for light and color made him a forerunner of the two greatest, Rembrandt and Vermeer." It seems safe to say that Ter Brugghen's "un-Dutch" altarpiece would likely have held little appeal for America's previous generations of collectors, with their

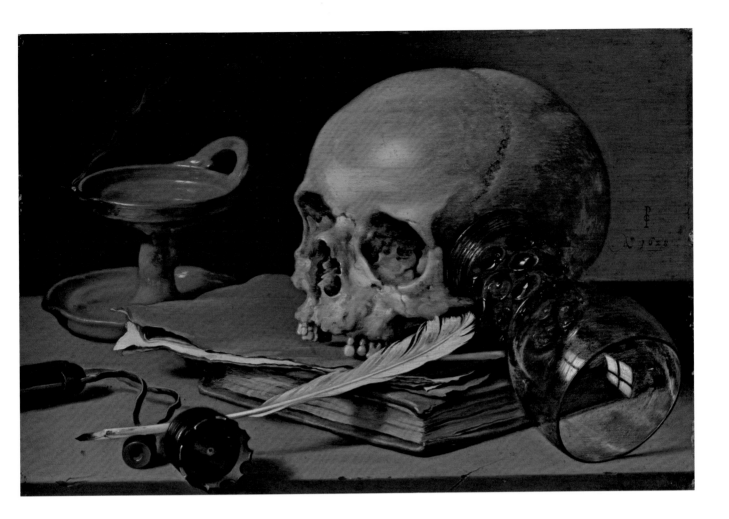

59. Pieter Claesz (Dutch, 1596/97–1660).
Still Life with a Skull and Writing Quill, 1628.
Oil on wood, 9½ x 14⅛ in. (24.1 x 35.9 cm).
Rogers Fund, 1949 (49.107)

obvious preference for naturalistic Dutch pictures. As such, its acquisition by the Museum signaled a major change in taste.

Five years after acquiring the Ter Brugghen, in 1961, the Museum made its most spectacular purchase to date when it bought Rembrandt's superb *Aristotle with a Bust of Homer* (Fig. 24) at the New York estate sale of Mrs. Alfred Erickson, after a bidding war of just four minutes. Its price—an unheard-of $2,300,000— set a new record in the auction rooms (see Fig. 61). Over the years some forty-two paintings have entered the Metropolitan's collections under Rembrandt's name. *Aristotle with a Bust of Homer* was the first and only one to be purchased by the Museum.

New York banker Robert Lehman (1891–1969; Fig. 62) bequeathed to the Museum, where he had served as chairman of the board of trustees from 1941 until his death, a collection that was perhaps America's last grand assembly of old masters in private hands that had its roots in the Gilded Age. Lehman's father, Philip (1861–1947), a partner in the investment banking firm of Lehman Brothers and a friend of Jules Bache's, had purchased his first pictures in the early 1910s. They included several Dutch paintings that are all now part of the Robert Lehman Collection at the Metropolitan, including a supposed Rembrandt, a De Hooch (Fig. 63), and a pair of Ter Borch portraits. With the help of advisers such as Bernard Berenson, the elder Lehman brought together a large and

60. Hendrick ter Brugghen (Dutch, 1588–1629). *The Crucifixion with the Virgin and Saint John*, ca. 1624–25. Oil on canvas, 61 x 40¼ in. (154.9 x 102.2 cm). Funds from various donors, 1956 (56.228)

61. "42,000 View $2,300,000 Rembrandt at Metropolitan," on the front page of the *New York Times*, November 19, 1961. The photograph shows Rembrandt's *Aristotle with a Bust of Homer* on view at the Metropolitan Museum, three days after its acquisition.

42,000 View $2,300,000 Rembrandt at Metropolitan

eclectic group of paintings, giving special attention to the early Italians and nineteenth-century French art. Robert Lehman, who became the collection's unofficial curator in later years, added more works to his father's assembly.

The principal Dutch painting in the Robert Lehman Collection is, of course, its autograph late Rembrandt, the uncompromising and masterful portrait of the young painter and etcher Gerard de Lairesse of about 1665–67 (Fig. 64). De Lairesse was born in Liège and in 1665, when he was twenty-four, settled in Amsterdam, where he was employed by the dealer Gerrit van Uylenburgh, through whom he may have met Rembrandt. By the time Rembrandt painted this extraordinary likeness of him, De Lairesse's facial features had been severely deformed by congenital syphilis. (De Lairesse's biographer Arnold Houbraken wrote in his *Groote Schouburgh* [1718–21] that two colleagues "gazed at him in horror because of his nauseating appearance" when he first arrived in Amsterdam in 1665.) In the 1670s and 1680s De Lairesse achieved great success in Amsterdam with his allegorical decorations in the then fashionable neoclassical style for the grand homes of the city's elite (see Fig. 58). After his disease caused him to go blind in about 1690 he became one of Holland's main art theorists, publishing his treatise on painting, *Het Groot Schilderboek*, in 1707. In his writings on the ideal in painting, De Lairesse opposed Rembrandt's late manner as it appears in this haunting portrait and in many other works that are now part of the Museum's collections, likening his application of paint to "liquid mud on the canvas."

64. Rembrandt van Rijn (Dutch, 1606–1669). *Gerard de Lairesse,* ca. 1665–67. Oil on canvas, 44⅜ x 34½ in. (112.7 x 87.6 cm). Robert Lehman Collection, 1975 (1975.1.140)

In the mid-1940s the portrait of De Lairesse was offered to the Museum of Fine Arts, Boston, for $50,000, a modest sum for such a major Rembrandt. Nonetheless, the picture was turned down by the museum's trustees supposedly after its director—"of good Boston family and [an admirer of] early Italian painting," as one source writes—introduced it as "a portrait of a syphilitic." Decades earlier, Wilhelm Bode, who wanted to acquire the Rembrandt for his Berlin museum, had used the same method to put off another interested party,

56

63. Pieter de Hooch (Dutch, 1629–1684). *Leisure Time in an Elegant Setting*, ca. 1663–65. 23 x 27⅜ in. (58.3 x 69.4 cm). Robert Lehman Collection, 1975 (1975.1.144)

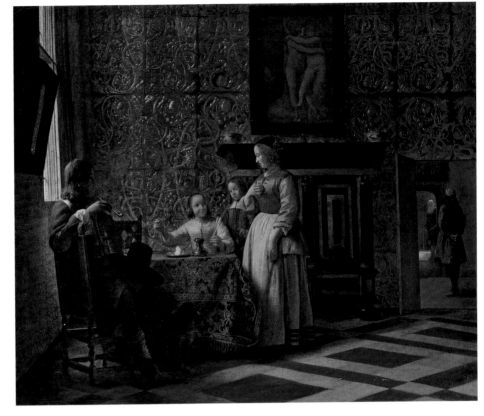

62. Robert L. Lehman (1891–1969), 1965

and successfully so, for at that time it was bought instead by one of his own protégé collectors, the Berlin banker Leopold Koppel (d. 1933). Years later, when Koppel's son, Albert, left Berlin as a consequence of World War II, he took the Rembrandt with him to Canada. Robert Lehman purchased it through Knoedler in May 1945, and the painting came to the Museum in 1975 as part of the Robert Lehman Collection, which today is housed in the Robert Lehman Wing.

65. Philips Wouwermans (Dutch, 1619–1668). *A Man and a Woman on Horseback*, ca. 1653–54. Oil on wood, 12⅛ x 16¼ in. (30.8 x 41.3 cm). Purchase, Pfeiffer Fund, Joseph Pulitzer Bequest, and Gift of Dr. Ernest G. Stillman, by exchange, 1971 (1971.48)

66. Nicolaes Maes (Dutch, 1634–1693). *Abraham Dismissing Hagar and Ishmael*, 1653. Oil on canvas, 34½ x 27½ in. (87.6 x 69.9 cm). Gift of Mrs. Edward Brayton, 1971 (1971.73)

The early 1970s brought an impressive series of Dutch pictures to the Museum, both through gifts from individual donors and through purchases. Leopold Koppel also once owned the early panel by Philips Wouwermans, *A Man and a Woman on Horseback* of about 1653–54 (Fig. 65), that the Museum bought in 1971. About 600 pictures by the prolific Wouwermans are known, and the Museum was surely "the last major one in the world to be without [a] Wouwermans," as John Walsh, at the time the Museum's curator of Dutch art, wrote shortly after he had secured *A Man and a Woman on Horseback*, which is in excellent condition. Also in 1971, the Museum acquired the earliest known dated picture by Nicolaes Maes, *Abraham Dismissing Hagar and Ishmael* of 1653 (Fig. 66), which had only recently been rediscovered in a private collection in Massachusetts. The owner's great-grandfather had bought the painting in Europe in 1810–11 and brought it across the Atlantic at a time when there were still only a few Dutch pictures in America.

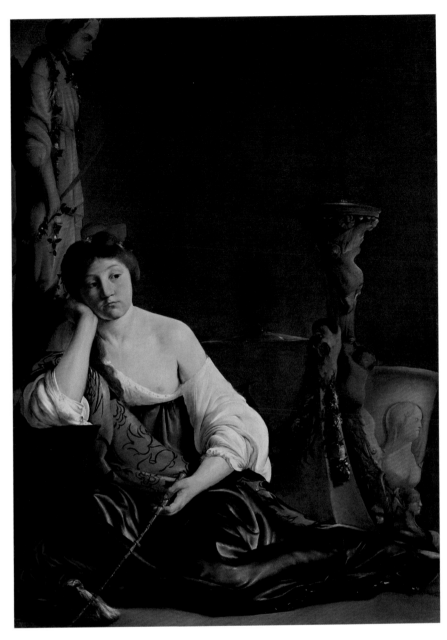

The Disillusioned Medea, then called *The Enchantress*, a large and puzzling picture of about 1640 by the Amersfoort Caravaggist Paulus Bor (Fig. 67), came to the Museum in 1972. Earlier in the possession of the Chigi family in Rome, the painting was long thought to be a work by the Neapolitan painter Salvator Rosa (1615–1673). "Who knows how [Bor] hit upon the idea of offering us this good-natured, plump, and homely *Enchantress*, so very Dutch, so exquisitely phlegmatic?" the art historian Vitale Bloch asked in 1949, apparently confused by the rather eccentric style, which can be described as a provincial Dutch painter's answer to the great Caravaggio and his circle. Bloch saw "something decidedly comic" in Bor's curious rendering of the enchantress, "the offspring of a distinctly flavoured and agreeable provincialism." Bor's canvas—"a Gentileschi from Amersfoort, so to speak!" Bloch called it—is likely the only work by the artist in the United States.

A splendid painting by the Utrecht Mannerist Abraham Bloemaert, *Moses Striking the Rock* (Fig. 68), was also acquired by the Museum in 1972, the first picture by a Dutch Mannerist to enter its collections. Dated 1596, the Bloemaert is now also the earliest work on view in the Museum's Dutch galleries. (The latest is *Landscape with Cattle*, given by Henry Marquand in 1890 as a Cuyp but recently attributed to one of Cuyp's most able imitators, Jacob van Strij, who probably painted it about 1800.) In 1974, partly with funds from Henry Marquand's bequest, the Museum bought *Vanitas Still Life* of 1603 (Fig. 69), an important work by Jacques de Gheyn the Elder, a wealthy amateur remembered mostly as a draftsman and printmaker. Only about twenty-one paintings by De Gheyn are known. The Museum's striking panel, thought to be the earliest *vanitas* still life in European painting, had only recently been rediscovered in a private collection in Sweden. *Forest Landscape with Two of Christ's Miracles* by David Vinckboons, a Dutch artist of Flemish origin whose landscapes reflect his connection with the Fleming Gillis van Coninxloo, came to the Museum in 1976 as part of the bequest of Harry Sperling, the New York art dealer who had bought

67. Paulus Bor (Dutch, ca. 1601–1669). *The Disillusioned Medea ("The Enchantress")*, ca. 1640. Oil on canvas, 61¼ x 44¼ in. (155.6 x 112.4 cm). Gift of Ben Heller, 1972 (1972.261). Formerly entitled *The Enchantress*, this work is now thought to represent Medea, daughter of the king of Colchis, one of the great sorceresses in Greek mythology. Having fallen in love with Jason, Medea used her witchcraft to help him steal the Golden Fleece. After Jason deserted her, she killed their children in revenge. Bor depicted the disillusioned Medea seated before an altar and a statue of Diana, contemplating her crimes.

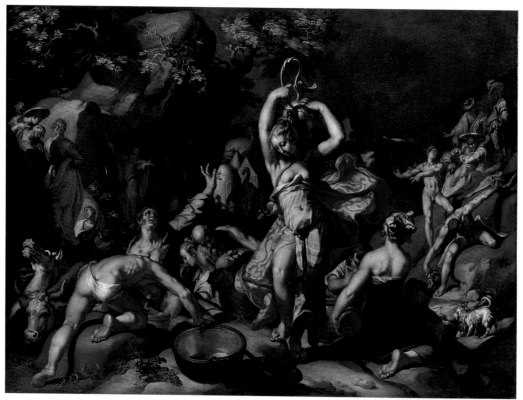

68. Abraham Bloemaert (Dutch, 1566–1651). *Moses Striking the Rock*,
1596. Oil on canvas, 31⅜ x 42½ in. (79.7 x 108 cm). Purchase, Gift
of Mary V. T. Eberstadt, by exchange, 1972 (1972.171)

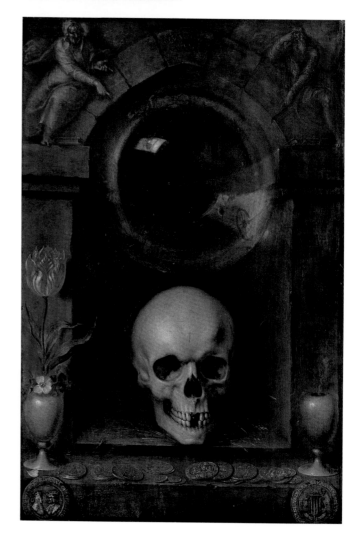

69. Jacques de Gheyn the Elder (Dutch, 1565–1629).
Vanitas Still Life, 1603. Oil on wood, 32½ x 21¼ in.
(82.6 x 54 cm). Charles B. Curtis, Marquand, Victor
Wilbour Memorial, and The Alfred N. Punnett
Endowment Funds, 1974 (1974.1)

70. Hendrick van Vliet (Dutch, 1611/12–1675). *Interior of the Oude Kerk, Delft*, 1660. Oil on canvas, 32½ x 26 in. (82.6 x 66 cm). Gift of Clarence Dillon, 1976 (1976.23.2)

Ter Brugghen's *Crucifixion* (Fig. 60) for the Museum in 1956. Sperling, the last surviving partner of Kleinberger Galleries, also left the Museum works by Nicolaes Eliasz Pickenoy, Barent Fabritius, and Pieter de Hooch. In 1976 the Museum also acquired a church interior by the Delft artist Hendrick van Vliet, *Interior of the Oude Kerk, Delft*, which is dated 1660 (Fig. 70). The painting was given by the investment banker Clarence Dillon (1882–1979), father of Douglas Dillon (1909–2003), the financier and former Secretary of the Treasury who became president of the Museum's board of trustees in 1970, served as its chairman from 1977 until 1983, and himself became a major benefactor.

The Museum's great Dutch triumph of the 1970s, however, was without question its fifth Vermeer, *Study of a Young Woman* of about 1665–67 (Fig. 71), a gift of Charles and Jayne Wrightsman, longtime trustees and exceptionally generous benefactors of the Museum (over the years they have donated some sixty paintings). The Wrightsman portrait may be one of the three Vermeers that were

described in the famed Dissius sale in Amsterdam in 1696 as "a *Tronie* [face or head] in Antique Dress, uncommonly artful." By 1829 the canvas was recorded in the collection of the Prince d'Arenberg, Brussels, where Théophile Thoré, Vermeer's great champion, rediscovered it in the late 1850s. The Arenberg Vermeer, a "head, unbelievably fanciful and pale as if struck by a moonbeam," reminded Thoré of Leonardo's *Mona Lisa*; he considered it to be worth more than a work by Philips Wouwermans valued at 100,000 francs, an enormous sum at the time. At the outbreak of World War I the Arenberg descendants decided to take their precious heirloom to their château in Germany for safekeeping. The Vermeer remained there for some four decades, unseen by connoisseurs and scholars, leading a number of them to conclude that it had been lost. One of the last Vermeers in private hands, the picture reappeared suddenly in the mid-1950s. In 1955 Charles Wrightsman bought it from the Arenberg descendants through the dealer Germain Seligman for $325,000. In an article entitled "No Biz Like Art Biz," *Time* magazine, quoting the price as $350,000, noted that judged as real estate, *Study of a Young Woman* was worth $1,252 per square inch (the Wall Street quarters of the House of Morgan, by comparison, were valued at $2.10 per square inch), making it an investment "as safe as General Motors."

Among the Museum's notable acquisitions of the early 1980s were a late panoramic landscape by Philips Koninck and Frans Post's *Brazilian Landscape* of 1650 (Fig. 72), which was a partial Rogers Fund purchase. In 1982 the Museum received some 500 objects from the collection of the late Jack Linsky (1897–1980) and his wife, Belle (1904–1987), who had made their fortune with Swingline, their stapler and office supplies company. It had taken the Linskys forty years to assemble their collection, which included not only old master paintings but also furniture, porcelains, and jewelry and which was valued at about $60 million when it came to the Museum. "I love the Met and I love the Frick; I love this city, and I owe it a debt," Belle Linsky (Fig. 73), who had immigrated to New York from Kiev as an infant, told the *New York Times* in March 1982. The couple had first started buying paintings during World War II. They never asked advice, according to Mrs. Linsky. "We were just two impulsive people who acquired things not with knowledge, but with heart. . . . When we saw something we loved, we had to have it." The five Dutch paintings the Museum received from the Linskys are *Portrait of a Man, Possibly a Botanist*, attributed to David Bailly (and, if he is indeed its author, probably the only Bailly in the United States); *The Van Moerkerken Family*, by Gerard ter Borch; and three genre pieces: Gabriël Metsu's *Woman Seated at a Window*; Cornelis Bisschop's *Young Woman and a Cavalier*, one of two Bisschops in the States; and a spirited work by Jan Steen, *The Dissolute Household* (Fig. 74). The Linskys' collection is kept together in perpetuity as a unified whole in The Jack and Belle Linsky Galleries (Fig. 75).

The steady stream of Dutch acquisitions in the 1970s and early 1980s became a slow trickle in the late 1980s and 1990s, due in part to the unfavorable tax reforms of 1986 and in part to the fact that the Museum decided to give preference,

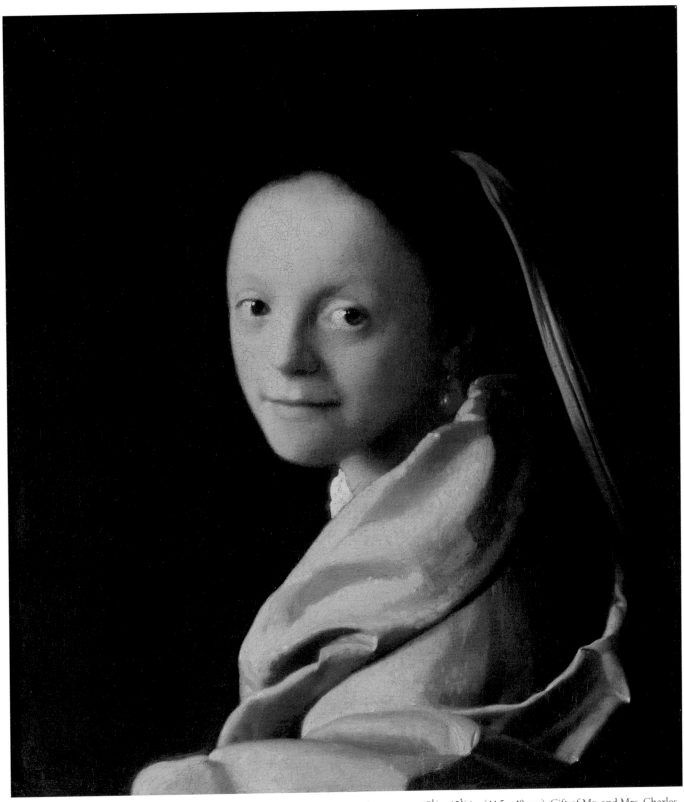

71. Johannes Vermeer (Dutch, 1632–1675). *Study of a Young Woman*, ca. 1665–67. Oil on canvas, 17½ x 15¾ in. (44.5 x 40 cm). Gift of Mr. and Mrs. Charles Wrightsman, in memory of Theodore Rousseau Jr., 1979 (1979.396.1)

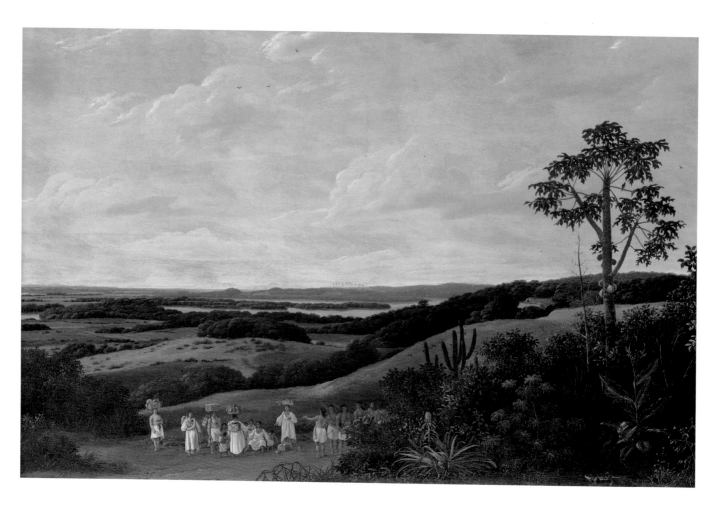

72. Frans Post (Dutch, 1612–1680). *A Brazilian Landscape*, 1650. Oil on wood, 24 x 36 in. (61 x 91.4 cm). Purchase, Rogers Fund, special funds, James S. Deely Gift, and Gift of Edna H. Sachs and other gifts and bequests, by exchange, 1981 (1981.318)

temporarily at least, to the acquisition of works belonging to the Flemish school. (The most noteworthy among the Museum's recent Flemish acquisitions is Peter Paul Rubens's *Forest at Dawn with a Deer Hunt* of about 1635, bought in 1990.) Still, three paintings were added to the Museum's Dutch collections in the last decade of the twentieth century, all purchased on the recommendation of Walter Liedtke, who has been curator of Dutch and Flemish paintings since 1980. That all three works were inspired by the art of Italy and France would have met with little enthusiasm in the early 1900s. A fine and much needed Italianate history picture, Bartholomeus Breenbergh's *Preaching of John the Baptist* of 1634 (Fig. 76), was bought in 1991 (as the only Dutch acquisition to be funded by the Annenberg Foundation). The classicist *Annunciation of the Death of the Virgin* (Fig. 77) by Samuel van Hoogstraten, a student and a critic of Rembrandt's, was purchased in 1992, partly with the funds donated by Jacob Rogers. The superb cabinet piece by the Utrecht Mannerist Joachim Wtewael, *The Golden Age* of 1605 (Fig. 78), came to the Museum in 1993.

The Wtewael was the last picture to enter the Dutch collections in the twentieth century. The first Dutch acquisition of the twenty-first century was an architectural piece by Emanuel de Witte, *Interior of the Oude Kerk, Delft* of 1650–52 (Fig. 79), which came to the Museum in 2001. Curator Walter Liedtke had had his eye on the De Witte for many years, realizing that such an early architectural

73. Belle Linsky (1904–1987), ca. 1980

view by a Delft artist would make a significant addition to the Dutch collections. Three years later, in 2004, the Museum received a fine miniature on copper by Nicolaes Maes, *Portrait of a Woman* of 1657. The smallest work in the Dutch collections (it measures just 4⅝ by 3⅜ inches) and one of only two seventeenth-century Dutch miniatures, it was a gift of the New York dealer Herman Shickman and his wife, Lila, who also donated works by Michiel Sweerts and Jean-Auguste-Dominique Ingres as well as (in large part) a late Caravaggio.

The latest bequest to enrich the Museum's Dutch holdings was that of the New York financial consultant Frits Markus (1909–1996) and his wife, Rita, who died in 2005. In addition to an exceptionally fine selection of twenty-two Dutch drawings, the Markuses' gift included a well-chosen group of eight Dutch pictures. Perhaps a bit surprisingly, the Markus paintings are, without exception, exactly the kind of traditional Dutch pictures that would have appealed to the Museum's benefactors of a much earlier age. Evidently, Mr. and Mrs. Markus, who were both natives of the Netherlands, shared the taste of late nineteenth-century America for naturalistic landscapes, portraits, and still lifes. Their

74. Jan Steen (Dutch, 1626–1679). *The Dissolute Household*, ca. 1663–64. Oil on canvas, 42½ x 35½ in. (108 x 90.2 cm). The Jack and Belle Linsky Collection, 1982 (1982.60.31)

75. The Dutch Room, The Jack and Belle Linsky Galleries, The Metropolitan Museum of Art. On the left wall is Cornelis Bisschop's *Young Woman and a Cavalier*. On the right wall, from left to right, are the small *Woman Seated at a Window*, by Gabriël Metsu; *Portrait of a Man, Possibly a Botanist*, attributed to David Bailly; and *The Van Moerkerken Family*, by Gerard ter Borch.

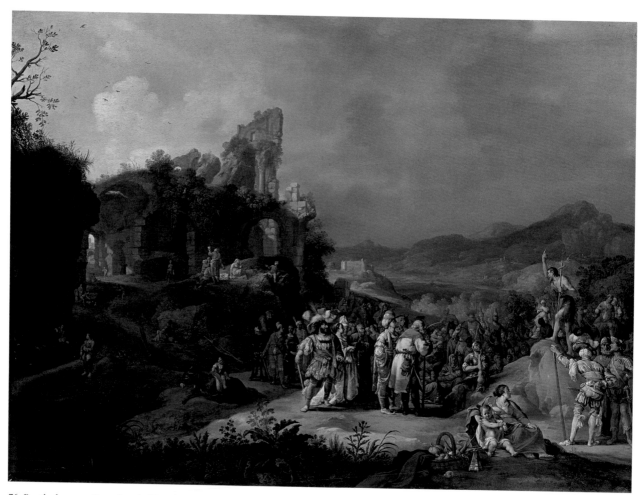

76. Bartholomeus Breenbergh (Dutch, 1598–1657). *The Preaching of John the Baptist*, 1634. Oil on wood, 21½ x 29⅝ in. (54.6 x 75.2 cm). Purchase, The Annenberg Foundation Gift, 1991 (1991.305)

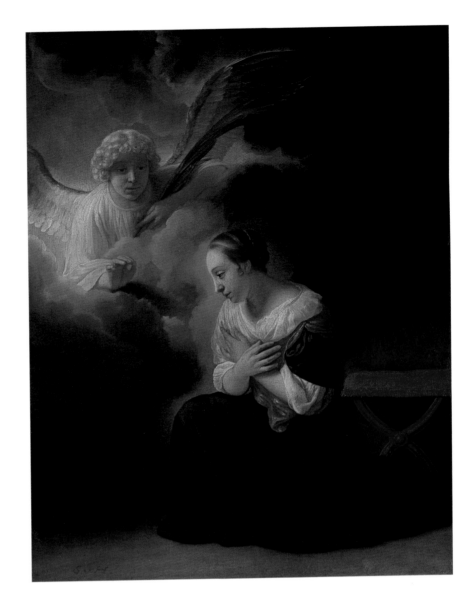

77. Samuel van Hoogstraten (Dutch, 1627–1678). *The Annunciation of the Death of the Virgin*, ca. 1670. Oil on canvas, 26 x 20¾ in. (66 x 52.7 cm). Purchase, Rogers Fund and Joseph Pulitzer Bequest, 1992 (1992.133)

bequest included four landscapes: a crisp, late Salomon van Ruysdael (*Fishing Boats on a River*), the Museum's seventh work by the master; two Van Goyens (*View of The Hague from the Northwest* and the especially noteworthy *Beach with Fishing Boats*); and an early winter landscape by the Middelburg painter Christoffel van den Berghe (Fig. 80), the first such scene to enter the Museum's collection and probably the only such work by the artist in the United States. The Markuses also left the Museum two small portrait pendants by Thomas de Keyser, *Portrait of a Man with a Shell* and *Portrait of a Woman with a Balance*, and a small study head in the style of Rembrandt, *Young Woman with a Red Necklace*, that half a century ago was still thought to have been executed by the master himself. The outstanding still life by the Haarlem artist Willem Claesz Heda, a monochrome *banketje* (breakfast piece) dated 1635 (Fig. 81), is perhaps the finest picture of the Markus ensemble and a valuable addition to the Museum's holdings of Dutch still lifes.

In 2007, 137 years after its founding, the Metropolitan Museum owns 228 Dutch pictures, from Abraham Bloemaert's *Moses Striking the Rock* of 1596 (Fig. 68) to Jacob van Strij's *Landscape with Cattle* of about 1800, making it the second largest

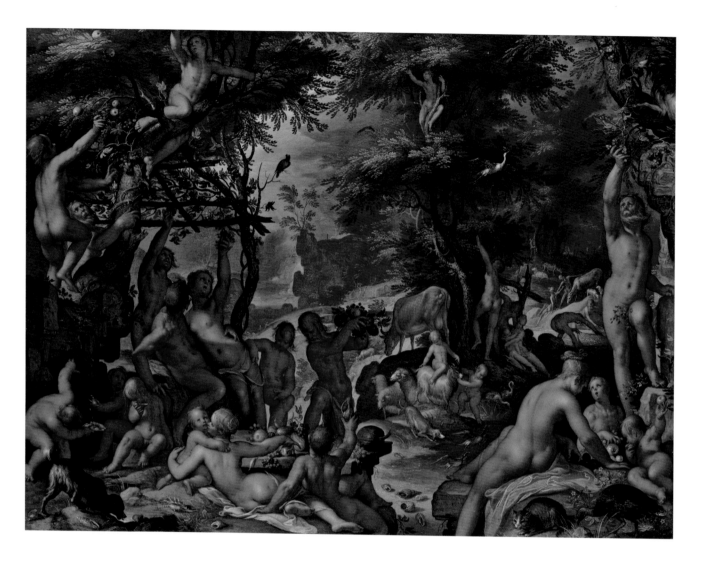

78. Joachim Wtewael (Dutch, 1566–1638). *The Golden Age*, 1605. Oil on copper, 8⅞ x 12 in. (22.5 x 30.5 cm). Purchase, The Edward Joseph Gallagher III Memorial Collection, Edward J. Gallagher Jr. Bequest; Lila Acheson Wallace Gift; special funds; and Gift of George Blumenthal, Bequest of Lillian S. Timken, The Collection of Giovanni P. Morosini, presented by his daughter Giulia, Gift of Mr. and Mrs. Nathaniel Spear Jr., Gift of Mrs. William M. Haupt, from the collection of Mrs. James B. Haggin, special funds, gifts, and bequests, by exchange, 1993 (1993.333)

repository of Dutch paintings in the United States (see Fig. 82). (The largest is the Philadelphia Museum of Art, thanks to John G. Johnson, the brilliant Gilded Age corporate lawyer who was also a trustee of the Metropolitan. Johnson was by no means a masterpiece collector, however, and unlike many of his New York contemporaries who were primarily interested in great paintings by great artists, he bought an overabundance of minor Dutch works.) The Metropolitan Museum of course counts some modest works among its plentiful Dutch holdings as well: the small landscape by Nicolaes Berchem from the 1871 Purchase, Collis Huntington's *Bacchus and Nymphs in a Landscape* by Abraham van Cuylenborch, and Michael Friedsam's *Barnyard Scene* by Anthonie van Borssom (see Fig. 48) are cases in point. And certainly there are the inevitable gaps: for example, the Museum has no work by Pieter Saenredam, the great painter of churches; no long desired winter landscape by Hendrick Avercamp, the pioneer of that genre; and no painting by Hendrick Goltzius or any other Haarlem Mannerist. The Utrecht Caravaggists are underrepresented, some might say, as are perhaps the Dutch Italianate painters; a genre piece by Gerrit van Honthorst or Dirck van Baburen would therefore be a welcome addition to the collection, as would an Italianate landscape by Jan Both, for instance. A work by Balthasar van der Ast

79. Emanuel de Witte (Dutch, ca. 1616–1692). *Interior of the Oude Kerk, Delft*, 1650–52. Oil on wood, 19 x 13⅝ in. (48.3 x 34.5 cm).
Purchase, Lila Acheson Wallace, Virgilia and Walter C. Klein, The Walter C. Klein Foundation, Edwin Weisl Jr., and Frank E.
Richardson Gifts, and Bequest of Theodore Rousseau and Gift of Lincoln Kirstein, by exchange, 2001 (2001.403)

80. Christoffel van den Berghe (Dutch, ca. 1590–1628 or later). *A Winter Landscape with Ice Skaters and an Imaginary Castle*. Oil on wood, 10¾ x 17¾ in. (27.3 x 45 cm.). From the Collection of Rita and Frits Markus, Bequest of Rita Markus, 2005 (2005.331.1). This picture was earlier attributed to Hendrick Avercamp (1585–1634), the pioneering painter of winter scenes. Recently, it has been given to Christoffel van den Berghe, who was active in Middelburg during the early seventeenth century and who left a small oeuvre of flower pieces and landscapes.

or Ambrosius Bosschaert, who broke new ground in the genre of Dutch still life, also remains high on the Museum's wish list.

Yet few would disagree that the Metropolitan's Dutch collections are by far the richest in America. Its wealth of Dutch masterpieces includes, by current standards, 20 autograph Rembrandts, 11 works by Frans Hals, 5 Vermeers, 7 De Hoochs, and 7 Ter Borchs—all assembled, remarkably, in less than a century and a half. After his visit here in 1893 Wilhelm Bode wrote that within a few decades the United States would be a country one needed to visit for its collections of old masters. If he were to return today, The Metropolitan Museum of Art's collection of Dutch paintings would surely be first on his itinerary.

81. Willem Claesz Heda (Dutch, 1594–1680). *Still Life with Oysters, a Silver Tazza, and Glassware*, 1635. Oil on wood, 19⅝ x 31¾ in. (49.8 x 80.6 cm). From the Collection of Rita and Frits Markus, Bequest of Rita Markus, 2005 (2005.331.4)

82. The Vermeer Room, Dutch Galleries, The Metropolitan Museum of Art. The Vermeer Room houses four of the Museum's five works by Johannes Vermeer (the fifth hangs in the Altman Galleries). On the left wall are (to the left) Vermeer's *Allegory of the Catholic Faith* and (to the right) Thomas de Keyser's *A Musician and His Daughter*. On the right wall are (from left to right) Nicolaes Maes's *Lacemaker*, three works by Vermeer (*Woman with a Lute*, *Study of a Young Woman*, and *Young Woman with a Water Pitcher*), and Emanuel de Witte's *Interior of the Oude Kerk, Delft*.

Select Bibliography

Baer, Ronni. *The Poetry of Everyday Life: Dutch Painting in Boston.* Exh. cat. Museum of Fine Arts, Boston. Boston, 2002.

Baetjer, Katharine. "Buying Pictures for New York: The Founding Purchase of 1871." *Metropolitan Museum Journal* 39 (2004), pp. 161–245.

Behrman, S. N. *Duveen: The Story of the Most Spectacular Art Dealer of All Time.* New York, 2002. Originally published 1952.

Bloch, Vitale. "Orlando." *Oud Holland* 64 (1949), pp. 104–8.

Bode, Wilhelm. "Alte Kunstwerke in den Sammlungen der Vereinigten Staaten." *Zeitschrift für bildende Kunst,* n.s., 6 (1895), pp. 13–19, 70–76.

———. "Old Art in the United States." *New York Times,* December 31, 1911, p. SM4.

Brimo, René. *L'évolution du goût aux États-Unis d'après l'histoire des collections.* Paris, 1938.

Broos, Ben, et al. *Great Dutch Paintings from America.* Exh. cat. Royal Cabinet of Paintings Mauritshuis, The Hague; Fine Arts Museums of San Francisco. The Hague and Zwolle, 1990. See especially Walter Liedtke, "Dutch Paintings in America: The Collectors and Their Ideals," pp. 14–59.

Constable, W. G. *Art Collecting in the United States of America: An Outline of a History.* London, 1964.

Cortissoz, Royal. "Old Dutch Masters," reprinted from the *New York Tribune,* September 19, 1909. *The Metropolitan Museum of Art Bulletin* 4 (1909), pp. 162–67.

———. "The Jules S. Bache Collection." *American Magazine of Art* 21, no. 5 (May 1930), pp. 245–61.

Cox, Kenyon. "Dutch Pictures in the Hudson-Fulton Exhibition." *Burlington Magazine* 16 (1909–10), pp. 178–84, 244–46, 302–6.

"Criticised by an Expert: Dr. Wilhelm Bode Talks about Art in This Country." *New York Times,* October 11, 1893, p. 1.

Fahy, Everett, et al. *The Wrightsman Pictures.* New York and New Haven, 2005.

Frelinghuysen, Alice Cooney, et al. *Splendid Legacy: The Havemeyer Collection.* Exh. cat. The Metropolitan Museum of Art. New York, 1993.

Fry, Roger. *Letters of Roger Fry.* Edited by Denys Sutton. 2 vols. New York, 1972.

Giltaij, Jeroen. *Ruffo en Rembrandt. Over een Siciliaanse verzamelaar in de zeventiende eeuw die drie schilderijen bij Rembrandt bestelde.* Zutphen, 1999.

Gimpel, René. *Diary of an Art Dealer.* Translated from French by John Rosenberg. New York, 1966. Paperback ed., New York, 1987.

Glueck, Grace. "Met Is Given $60 Million Linsky Art Collection. Belle Linsky Donates Collection to the Met." *New York Times,* March 4, 1982, pp. A1, C22.

Grant, J. Kirby. "Mrs. Collis P. Huntington's Collection." *Connoisseur* 20 (January 1908), pp. 2–15.

Hadley, Rollin van N., ed. *The Letters of Bernard Berenson and Isabella Stewart Gardner, 1887–1924; with Correspondence by Mary Berenson.* Boston, 1987.

Haskell, Francis. "The Benjamin Altman Bequest." *Metropolitan Museum Journal* 3 (1970), pp. 259–80.

Havemeyer, Louisine W. *Sixteen to Sixty: Memoirs of a Collector.* New annotated ed., edited by Susan Alyson Stein. New York, 1993. Originally published 1961.

Howe, Winifred Eva. *A History of The Metropolitan Museum of Art, with a Chapter on the Early Institutions of Art in New York.* 2 vols. New York, 1913 (vol. 1) and 1946 (vol. 2).

The Jack and Belle Linsky Collection in The Metropolitan Museum of Art. New York, 1984.

[James, Henry]. "The Dutch and Flemish Pictures in New York." *Atlantic Monthly* 29, no. 176 (June 1872), pp. 757–63. Also reprinted in *The Painter's Eye: Notes and Essays on the Pictorial Arts by Henry James,* edited by John L. Sweeney, pp. 52–66, London, 1956.

James, Henry. *The American Scene.* New York, 1994. Originally published 1907.

Liedtke, Walter. *Dutch Paintings in The Metropolitan Museum of Art.* 2 vols. New York, 2007.

Liedtke, Walter, et al. *Vermeer and the Delft School.* Exh. cat. The Metropolitan Museum of Art; National Gallery, London. New York, 2001.

Minty, Nancy T. "Dutch and Flemish Seventeenth-Century Art in America, 1800–1940: Collections, Connoisseurship, and Perceptions." Ph.D. diss., New York University, Institute of Fine Arts, 2003.

Pène du Bois, Guy. "Famous American Collections: The Collection of Mr. Michael Friedsam." *Arts and Decoration* 7 (June 1917), pp. 397–402.

Pope-Hennessy, John. "Roger Fry and The Metropolitan Museum of Art." In: *Oxford, China, and Italy: Writings in Honour of Sir Harold Acton on His Eightieth Birthday,* edited by Edward Chaney and Neil Ritchie, pp. 229–40. London, 1984.

Quodbach, Esmée. "'The Last of the American Versailles': The Widener Collection at Lynnewood Hall." *Simiolus* 29 (2002), pp. 42–96.

———. "'Rembrandt's 'Gilder' Is Here': How America Got Its First Rembrandt and France Lost Many of Its Old Masters." *Simiolus* 31 (2004), pp. 90–107.

Reitlinger, Gerald. *The Economics of Taste.* Vol. [1], *The Rise and Fall of Picture Prices, 1760–1960.* Vol. 2, *The Rise and Fall of Objects d'Art Prices since 1750.* Vol. 3, *The Art Market in the 1960s.* London, 1961–70.

Rembrandt/Not Rembrandt in The Metropolitan Museum of Art: Aspects of Connoisseurship. Vol. 1, *Paintings: Problems and Issues,* by Hubert von Sonnenburg. Vol. 2, *Paintings, Drawings, and Prints: Art-Historical Perspectives,* by Walter Liedtke et al. Exh. cat. The Metropolitan Museum of Art. New York, 1995.

Rousseau, Theodore. "Aristotle Contemplating the Bust of Homer." *The Metropolitan Museum of Art Bulletin,* n.s., 20, no. 5 (January 1962), pp. 149–56.

Saarinen, Aline B. *The Proud Possessors: The Lives, Times, and Tastes of Some Adventurous American Art Collectors.* New York, 1958.

Seligman, Germain. *Merchants of Art: 1880–1960, Eighty Years of Professional Collecting.* New York, 1961.

Sterling, Charles, et al. *The Robert Lehman Collection, II: Fifteenth- to Eighteenth-Century European Paintings. France, Central Europe, The Netherlands, Spain, and Great Britain.* New York: The Metropolitan Museum of Art, 1998.

Strouse, Jean. "J. Pierpont Morgan: Financier and Collector." *The Metropolitan Museum of Art Bulletin,* n.s., 57, no. 3 (Winter 2000).

Sutton, Peter C. *A Guide to Dutch Art in America.* Grand Rapids and Kampen, 1986.

Tomkins, Calvin. *Merchants and Masterpieces: The Story of The Metropolitan Museum of Art.* New York, 1970.

Valentiner, Wilhelm R. *The Hudson-Fulton Celebration: Catalogue of an Exhibition Held in The Metropolitan Museum of Art.* Vol. 1, *Catalogue of a Collection of Paintings by Dutch Masters.* Exh. cat. The Metropolitan Museum of Art. New York, 1909.

Virch, Claus. "The Crucifixion by Hendrick Terbrugghen." *The Metropolitan Museum of Art Bulletin,* n.s., 16, no. 8 (April 1958), pp. 217–26.

Walsh, John, Jr. "New Dutch Paintings at the Metropolitan Museum." *Apollo* 99 (May 1974), pp. 340–49.

Weitzenhoffer, Frances. *The Havemeyers: Impressionism Comes to America.* New York, 1986.

Wharton, Edith. *A Backward Glance.* New York, 1998. Originally published 1934.

Wheelock, Arthur K., Jr., et al. *Johannes Vermeer.* Exh. cat. National Gallery of Art, Washington, D.C.; Royal Cabinet of Paintings Mauritshuis, The Hague. Washington, D.C., The Hague, and Zwolle, 1995.

Young, Dorothy Weir. *The Life and Letters of J. Alden Weir.* Edited by Lawrence W. Chisolm. New Haven, 1960.

Sources of Quotations

pp. 5–6: Johnston to Blodgett, February 10 and 22, 1872, in Howe 1913, pp. 144–47. pp. 6–7: [James] 1872, pp. 757, 759, 760, 763, 758. p. 8: ibid., p. 763; George P. Putnam, report to the MMA trustees, May 20, 1872, quoted in Howe 1913, p. 149. p. 10: James (1907) 1994, p. 143; Wharton (1934) 1998, p. 148; *Dictionary of American Biography,* vol. 12, pp. 292–93; Weir to his parents, n.d., in Young 1960, p. 159. p. 11: London *Times,* March 1884, quoted in Reitlinger 1961–70, vol. 1, p. 176; Marquand to Weir, n.d., in Young 1960, p. 160. pp. 12–14: *Collector* 3, no. 6 (1892), p. 81. p. 14: Saarinen 1958, p. 153. pp. 15–16: "Criticised by an Expert" 1893. p. 18: "Art and Artists," *New York Times,* June 30, 1900, p. BR4; Cox 1909–10, p. 246. pp. 18–19: Seligman 1961, p. 18. p. 20: Charles A. Shriver, "Jacob S. Rogers," typescript, Watson Library, Metropolitan Museum, n.d. [after 1906]; Rogers's will, quoted in Howe 1913, p. 271; William E. Dodge to Marquand, n.d., in ibid., p. 272; MMA Annual Report 1905, p. 11; Fry to R. C. Trevelyan, September 10, 1906, in Fry 1972, vol. 1, p. 268. p. 22: Grant 1908, p. 5. p. 23: Giltaij 1999, pp. 44, 126. p. 29: Cortissoz 1909, p. 162; Cox 1909–10, p. 178. pp. 29–30: Bode 1911. p. 30: memo dated 1904, archives of Knoedler & Co., New York. p. 33: Berenson to Gardner, February 1913, in Hadley 1987, p. 500; Bode to Duveen, May 14 and 23, 1913, Duveen file, Department of European Paintings, Metropolitan Museum, cited in Haskell 1970, p. 277. p. 35: ibid., p. 278n65; John W. Alexander, quoted in Tomkins 1970, p. 174. p. 39: Wheelock et al. 1995, pp. 194, 195n35; Belle da Costa Greene to H. van Slochem, December 6, 1911, Pierpont Morgan Library, New York. pp. 40 and 41: Louis S. Levy, "The Jules S. Bache Collection," typescript, Department of European Paintings, Metropolitan Museum, n.d. [after 1943], pp. 6–8. p. 40: Cortissoz 1930, p. 245. p. 47: Levy, "Bache Collection," pp. 6, 17. p. 50: Nigel Foxell, "The Met's Terbrugghen 'Crucifixion,'" typescript, Department of European Paintings, Metropolitan Museum, 2007. p. 52: Virch 1958, pp. 217, 228. p. 55: Houbraken 1718–21, vol. 1, p. 285, quoted in trans. by E. Haverkamp-Begemann in Sterling et al. 1998, p. 144; De Lairesse 1707, vol. 1, pp. 324–25. p. 56: Rowland Burdon-Miller, quoted in Baer 2002, p. 48. p. 58: Walsh 1974, p. 348. p. 59: Bloch 1949, pp. 107–8. p. 62: Dissius sale catalogue, quoted in Liedtke 2007, p. 888; Thoré, quoted in trans. in Fahy et al. 2005, p. 134; Glueck 1982, p. A1.